ITALIAN VILLAS AND
THEIR GARDENS

ITALIAN VILLAS
AND THEIR GARDENS

BY

EDITH WHARTON

ILLUSTRATED WITH PICTURES BY
MAXFIELD PARRISH
AND BY PHOTOGRAPHS

A DA CAPO PAPERBACK

Library of Congress Cataloging in Publication Data

Wharton, Edith Newbold Jones, 1862-1937.
 Italian villas and their gardens.

 (A Da Capo paperback)
 Reprint of the ed. published by the Century Co., New
York.
 1. Architecture, Domestic—Italy. 2. Landscape
architecture—Italy. I. Title.
[NA7594.W46 1976b] 945 76-10659
ISBN 0-306-80048-9 pbk.

ISBN 0-306-80048-9

First Paperback Printing 1976

This Da Capo Paperback edition of *Italian Villas and Their Gardens*
is an unabridged republication of the first edition
published in New York in 1904.
The color illustrations, included in the pagination of the
original book, have been grouped together for this reprint
edition; and consequently there are gaps in the page numbering.
But no material has been added or deleted for the
Da Capo reprint edition.

Published by Da Capo Press, Inc.
A Subsidiary of Plenum Publishing Corporation
227 West 17th Street
New York, N.Y. 10011

TO

VERNON LEE

WHO, BETTER THAN ANY ONE ELSE, HAS UNDERSTOOD
AND INTERPRETED THE GARDEN-MAGIC
OF ITALY

CONTENTS

LIST OF ILLUSTRATIONS

LIST OF ILLUSTRATIONS

LIST OF ILLUSTRATIONS

LIST OF ILLUSTRATIONS

ITALIAN VILLAS AND
THEIR GARDENS

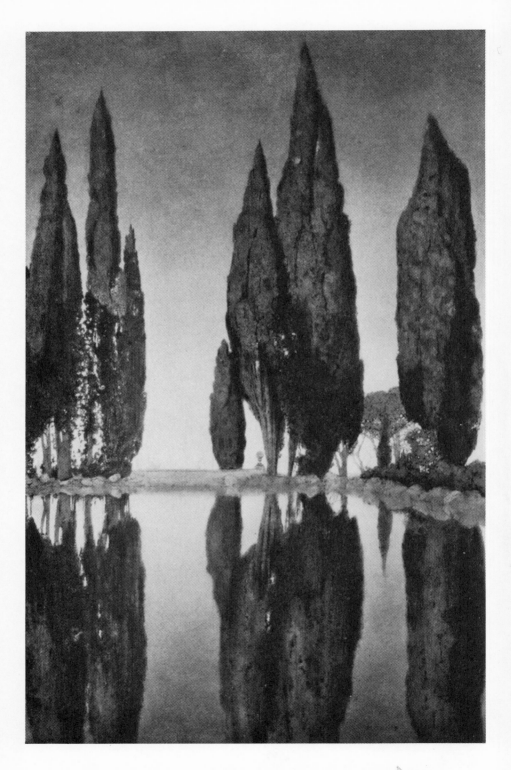

THE RESERVOIR, VILLA FALCONIERI, FRASCATI

ITALIAN VILLAS AND THEIR GARDENS

INTRODUCTION

ITALIAN GARDEN-MAGIC

THOUGH it is an exaggeration to say that there are no flowers in Italian gardens, yet to enjoy and appreciate the Italian garden-craft one must always bear in mind that it is independent of floriculture.

The Italian garden does not exist for its flowers; its flowers exist for it: they are a late and infrequent adjunct to its beauties, a parenthetical grace counting only as one more touch in the general effect of enchantment. This is no doubt partly explained by the difficulty of cultivating any but spring flowers in so hot and dry a climate, and the result has been a wonderful development of the more permanent effects to be obtained from the three other factors in garden-composition — marble, water and perennial verdure — and the achievement, by their skilful blending, of a charm independent of the seasons.

It is hard to explain to the modern garden-lover,

5

whose whole conception of the charm of gardens is formed of successive pictures of flower-loveliness, how this effect of enchantment can be produced by anything so dull and monotonous as a mere combination of clipped green and stone-work.

The traveller returning from Italy, with his eyes and imagination full of the ineffable Italian garden-magic, knows vaguely that the enchantment exists; that he has been under its spell, and that it is more potent, more enduring, more intoxicating to every sense than the most elaborate and glowing effects of modern horticulture; but he may not have found the key to the mystery. Is it because the sky is bluer, because the vegetation is more luxuriant? Our midsummer skies are almost as deep, our foliage is as rich, and perhaps more varied; there are, indeed, not a few resemblances between the North American summer climate and that of Italy in spring and autumn.

Some of those who have fallen under the spell are inclined to ascribe the Italian garden-magic to the effect of time; but, wonder-working as this undoubtedly is, it leaves many beauties unaccounted for. To seek the answer one must go deeper: the garden must be studied in relation to the house, and both in relation to the landscape. The garden of the Middle Ages, the garden one sees in old missal illuminations and in early woodcuts, was a mere patch of ground within the castle precincts, where "simples" were grown around a central well-

head and fruit was espaliered against the walls. But in the rapid flowering of Italian civilization the castle walls were soon thrown down, and the garden expanded, taking in the fish-pond, the bowling-green, the rose-arbour and the clipped walk. The Italian country house, especially in the centre and the south of Italy, was almost always built on a hillside, and one day the architect looked forth from the terrace of his villa, and saw that, in his survey of the garden, the enclosing landscape was naturally included: the two formed a part of the same composition.

The recognition of this fact was the first step in the development of the great garden-art of the Renaissance: the next was the architect's discovery of the means by which nature and art might be fused in his picture. He had now three problems to deal with: his garden must be adapted to the architectural lines of the house it adjoined; it must be adapted to the requirements of the inmates of the house, in the sense of providing shady walks, sunny bowling-greens, parterres and orchards, all conveniently accessible; and lastly it must be adapted to the land-scape around it. At no time and in no country has this triple problem been so successfully dealt with as in the treatment of the Italian country house from the beginning of the sixteenth to the end of the eighteenth century; and in the blending of different elements, the subtle transition from the fixed and formal lines of art to the shifting and irregular lines of nature, and lastly

in the essential convenience and livableness of the garden, lies the fundamental secret of the old garden-magic.

However much other factors may contribute to the total impression of charm, yet by eliminating them one after another, by *thinking away* the flowers, the sunlight, the rich tinting of time, one finds that, underlying all these, there is the deeper harmony of design which is independent of any adventitious effects. This does not imply that a plan of an Italian garden is as beautiful as the garden itself. The more permanent materials of which the latter is made — the stonework, the evergreen foliage, the effects of rushing or motionless water, above all the lines of the natural scenery — all form a part of the artist's design. But these things are as beautiful at one season as at another ; and even these are but the accessories of the fundamental plan. The inherent beauty of the garden lies in the grouping of its parts — in the converging lines of its long ilex-walks, the alternation of sunny open spaces with cool woodland shade, the proportion between terrace and bowling-green, or between the height of a wall and the width of a path. None of these details was negligible to the landscape-architect of the Renaissance : he considered the distribution of shade and sunlight, of straight lines of masonry and rippled lines of foliage, as carefully as he weighed the relation of his whole composition to the scene about it.

Then, again, any one who studies the old Italian

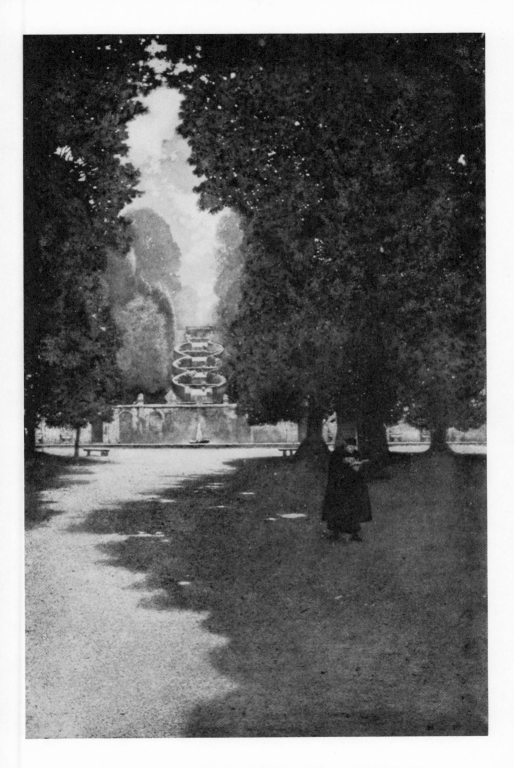

THE CASCADE, VILLA TORLONIA, FRASCATI

gardens will be struck with the way in which the architect broadened and simplified his plan if it faced a grandiose landscape. Intricacy of detail, complicated groupings of terraces, fountains, labyrinths and porticoes, are found in sites where there is no great sweep of landscape attuning the eye to larger impressions. The farther north one goes, the less grand the landscape becomes and the more elaborate the garden. The great pleasure-grounds overlooking the Roman Campagna are laid out on severe and majestic lines: the parts are few; the total effect is one of breadth and simplicity.

It is because, in the modern revival of gardening, so little attention has been paid to these first principles of the art that the garden-lover should not content himself with a vague enjoyment of old Italian gardens, but should try to extract from them principles which may be applied at home. He should observe, for instance, that the old Italian garden was meant to be lived in — a use to which, at least in America, the modern garden is seldom put. He should note that, to this end, the grounds were as carefully and conveniently planned as the house, with broad paths (in which two or more could go abreast) leading from one division to another; with shade easily accessible from the house, as well as a sunny sheltered walk for winter; and with effective transitions from the dusk of wooded alleys to open flowery spaces or to the level sward of the bowling-

green. He should remember that the terraces and formal gardens adjoined the house, that the ilex or laurel walks beyond were clipped into shape to effect a transition between the straight lines of masonry and the untrimmed growth of the woodland to which they led, and that each step away from architecture was a nearer approach to nature.

The cult of the Italian garden has spread from England to America, and there is a general feeling that, by placing a marble bench here and a sun-dial there, Italian "effects" may be achieved. The results produced, even where much money and thought have been expended, are not altogether satisfactory; and some critics have thence inferred that the Italian garden is, so to speak, *untranslatable*, that it cannot be adequately rendered in another landscape and another age.

Certain effects, those which depend on architectural grandeur as well as those due to colouring and age, are no doubt unattainable; but there is, none the less, much to be learned from the old Italian gardens, and the first lesson is that, if they are to be a real inspiration, they must be copied, not in the letter but in the spirit. That is, a marble sarcophagus and a dozen twisted columns will not make an Italian garden; but a piece of ground laid out and planted on the principles of the old garden-craft will be, not indeed an Italian garden in the literal sense, but, what is far better, *a garden as well adapted to its surroundings as were the models which inspired it.*

ITALIAN GARDEN-MAGIC

This is the secret to be learned from the villas of Italy; and no one who has looked at them with this object in view will be content to relapse into vague admiration of their loveliness. As Browning, in passing Cape St. Vincent and Trafalgar Bay, cried out:

"Here and here did England help me: how can I help England?" — say,

so the garden-lover, who longs to transfer something of the old garden-magic to his own patch of ground at home, will ask himself, in wandering under the umbrella-pines of the Villa Borghese, or through the box-par-terres of the Villa Lante: What can I bring away from here? And the more he studies and compares, the more inevitably will the answer be: "Not this or that amputated statue, or broken bas-relief, or fragmentary effect of any sort, but a sense of the informing spirit — an understanding of the gardener's purpose, and of the uses to which he meant his garden to be put."

FLORENTINE VILLAS

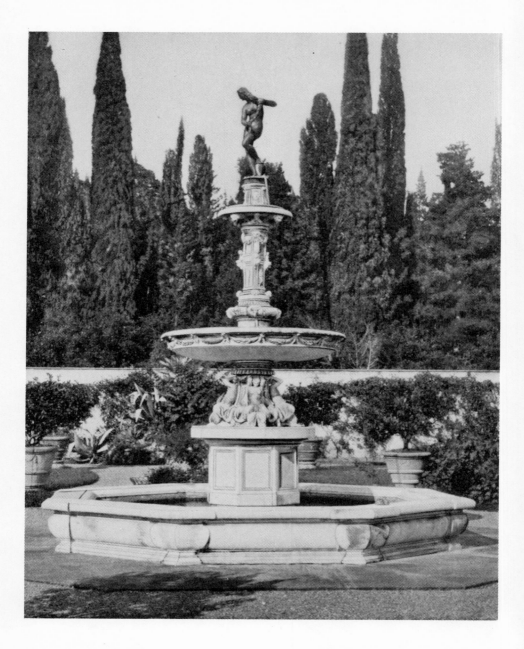

FOUNTAIN OF VENUS, VILLA PETRAJA, FLORENCE

FLORENTINE VILLAS

FOR centuries Florence has been celebrated for her villa-clad hills. According to an old chronicler, the country houses were more splendid than those in the town, and stood so close-set among their olive-orchards and vineyards that the traveller "thought himself in Florence three leagues before reaching the city."

Many of these houses still survive,. strongly planted on their broad terraces, from the fifteenth-century farmhouse-villa, with its projecting eaves and square tower, to the many-windowed *maison de plaisance* in which the luxurious nobles of the seventeenth century spent the gambling and chocolate-drinking weeks of the vintage season. It is characteristic of Florentine thrift and conservatism that the greater number of these later and more pretentious villas are merely additions to the plain old buildings, while, even in the rare cases where the whole structure is new, the baroque exuberance which became fashionable in the seventeenth century is tempered by a restraint and severity peculiarly Tuscan.

So numerous and well preserved are the buildings

of this order about Florence that the student who should attempt to give an account of them would have before him a long and laborious undertaking; but where the villa is to be considered in relation to its garden, the task is reduced to narrow limits. There is perhaps no region of Italy so rich in old villas and so lacking in old

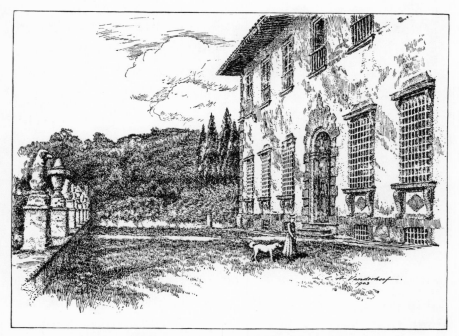

VILLA GAMBERAIA, AT SETTIGNANO, NEAR FLORENCE

gardens as the neighbourhood of Florence. Various causes have brought about this result. The environs of Florence have always been frequented by the wealthy classes, not only Italian but foreign. The Tuscan nobility have usually been rich enough to alter their gardens in accordance with the varying horticultural

fashions imported from England and France; and the English who have colonized in such numbers the slopes above the Arno have contributed not a little to the destruction of the old gardens by introducing into their horticultural plans two features entirely alien to the Tuscan climate and soil, namely, lawns and deciduous shade-trees.

Many indeed are the parterres and terraces which have disappeared before the Britannic craving for a lawn, many the olive-orchards and vineyards which must have given way to the thinly dotted " specimen trees " so dear to the English landscape-gardener, who is still, with rare exceptions, the slave of his famous eighteenth-century predecessors, Repton and " Capability Brown," as the English architect is still the descendant of Pugin and the Gothic revival. This Anglicization of the Tuscan garden did not, of course, come only from direct English influence. The *jardin anglais* was fashionable in France when Marie Antoinette laid out the Petit Trianon, and Herr Tuckermann, in his book on Italian gardens, propounds a theory, for which he gives no very clear reasons, to the effect that the naturalistic school of gardening actually originated in Italy, in the Borghese gardens in Rome, which he supposes to have been laid out more or less in their present form by Giovanni Fontana, as early as the first quarter of the seventeenth century.

It is certain, at any rate, that the Florentines adopted

the new fashion early in the nineteenth century, as is shown—to give but one instance—in the vast Torrigiani gardens, near the Porta Romana, laid out by the Marchese Torrigiani about 1830 in the most approved "landscape" style, with an almost complete neglect of the characteristic Tuscan vegetation and a corresponding disregard of Italian climate and habits. The large English colony has, however, undoubtedly done much to encourage, even in the present day, the alteration of the old gardens and the introduction of alien vegetation in those which have been partly preserved. It is, for instance, typical of the old Tuscan villa that the farm, or *podere*, should come up to the edge of the terrace on which the house stands; but in most cases where old villas have been bought by foreigners, the vineyards and olive-orchards near the house have been turned into lawns dotted with plantations of exotic trees. Under these circumstances it is not surprising that but few unaltered gardens are to be found near Florence To learn what the old Tuscan garden was, one must search the environs of the smaller towns, and there are more interesting examples about Siena than in the whole circuit of the Florentine hills.

The old Italian architects distinguished two classes of country houses: the *villa suburbana*, or *maison de plaisance* (literally the pleasure-house), standing within or just without the city walls, surrounded by pleasure-grounds and built for a few weeks' residence; and the

country house, which is an expansion of the old farm, and stands generally farther out of town, among its fields and vineyards—the seat of the country gentleman living on his estates. The Italian pleasure-garden did not reach its full development till the middle of the sixteenth century, and doubtless many of the old Florentine villas, the semi-castle and the quasi-farm of the fourteenth century, stood as they do now, on a bare terrace among the vines, with a small walled enclosure for the cultivation of herbs and vegetables. But of the period in which the garden began to be a studied architectural extension of the house, few examples are to be found near Florence.

The most important, if not the most pleasing, of Tuscan pleasure-gardens lies, however, within the city walls. This is the Boboli garden, laid out on the steep hillside behind the Pitti Palace. The plan of the Boboli garden is not only magnificent in itself, but interesting as one of the rare examples, in Tuscany, of a Renaissance garden still undisturbed in its main outlines. Eleonora de' Medici, who purchased the Pitti Palace in 1549, soon afterward acquired the neighbouring ground, and the garden was laid out by Il Tribolo, continued by Buontalenti, and completed by Bartolommeo Ammanati, to whom is also due the garden façade of the palace. The scheme of the garden is worthy of careful study, though in many respects the effect it now produces is far less impressive than its designers intended. Prob-

ably no grounds of equal grandeur and extent have less of that peculiar magic which one associates with the old Italian garden—a fact doubtless due less to defects of composition than to later changes in the details of planting and decoration. Still, the main outline remains and is full of instruction to the garden-lover.

The palace is built against the steep hillside, which is dug out to receive it, a high retaining-wall being built far enough back from the central body of the house to allow the latter to stand free. The ground floor of the palace is so far below ground that its windows look across a paved court at the face of the retaining-wall, which Ammanati decorated with an architectural composition representing a grotto, from which water was meant to gush as though issuing from the hillside. This grotto he surmounted with a magnificent fountain, standing on a level with the first-floor windows of the palace and with the surrounding gardens. The arrangement shows ingenuity in overcoming a technical difficulty, and the effect, from the garden, is very successful, though the well-like court makes an unfortunate gap between the house and its grounds.

Behind the fountain, and in a line with it, a horseshoe-shaped amphitheatre has been cut out of the hillside, surrounded by tiers of stone seats adorned with statues in niches and backed by clipped laurel hedges, behind which rise the ilex-clad slopes of the upper gardens. This amphitheatre is one of the triumphs of Italian

ENTRANCE TO UPPER GARDEN, BOBOLI GARDEN, FLORENCE

garden-architecture. In general design and detail it belongs to the pure Renaissance, without trace of the heavy and fantastic *barrochismo* which, half a century later, began to disfigure such compositions in the villas near Rome. Indeed, comparison with the grotesque garden-architecture of the Villa d'Este at Tivoli, which is but little later in date, shows how long the Tuscan sense of proportion and refinement of taste resisted the ever-growing desire to astonish instead of charming the spectator.

On each side of the amphitheatre, clipped ilex-walks climb the hill, coming out some distance above on a plateau containing the toy lake with its little island, the Isola Bella, which was once the pride of the Boboli garden. This portion of the grounds has been so stripped of its architectural adornments and of its sur-rounding vegetation that it is now merely forlorn ; and the same may be said of the little upper garden, reached by an imposing flight of steps and commanding a wide view over Florence. One must revert to the architect's plan to see how admirably adapted it was to the difficul-ties of the site he had to deal with, and how skilfully he harmonized the dense shade of his ilex-groves with the great open spaces and pompous architectural effects necessary in a garden which was to form a worthy set-ting for the pageants of a Renaissance court. It is interesting to note in this connection that the flower-garden, or *giardino segreto*, which in Renaissance gar-

dens almost invariably adjoins the house, has here been
relegated to the hilltop, doubtless because the only level
space near the palace was required for state ceremonials
and theatrical entertainments rather than for private
enjoyment.

It is partly because the Boboli is a court-garden, and
not designed for private use, that it is less interesting
and instructive than many others of less importance.
Yet the other Medicean villas near Florence, though
designed on much simpler lines, have the same lack of
personal charm. It is perhaps owing to the fact that
Florence was so long under the dominion of one all-
powerful family that there is so little variety in her
pleasure-houses. Pratolino, Poggio a Caiano, Cafag-
giuolo, Careggi, Castello and Petraia, one and all,
whatever their origin, soon passed into the possessor-
ship of the Medici, and thence into that of the Austrian
grand dukes who succeeded them; and of the three
whose gardens have been partly preserved, Castello,
Petraia and Poggio Imperiale, it may be said that they
have the same impersonal official look as the Boboli.

Castello and Petraia, situated a mile apart beyond the
villáge of Quarto, were both built by Buontalenti, that
brilliant pupil of Ammanati's who had a share in the
planning of the gardens behind the Pitti. Castello
stands on level ground, and its severely plain façade,
with windows on consoles and rusticated doorway, faces
what is now a highway, though, according to the print

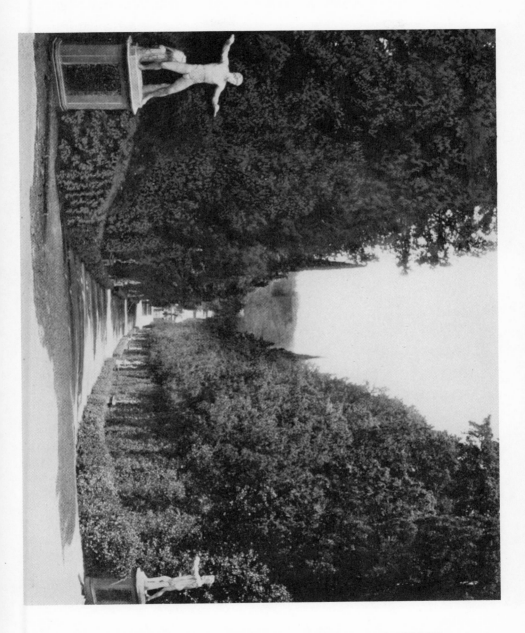

CYPRESS ALLEY, BOBOLI GARDEN, FLORENCE

of Zocchi, the eighteenth-century engraver, a semicircular space enclosed in a low wall once extended between the house and the road, as at the neighbouring Villa Corsini and at Poggio Imperiale. It was an admirable rule of the old Italian architects, where the garden-space was small and where the site permitted, to build their villas facing the road, so that the full extent of the grounds was secured to the private use of the inmates, instead of being laid open by a public approach to the house. This rule is still followed by French villa-architects, and it is exceptional in France to see a villa entered from its grounds when it may be approached directly from the highroad.

Behind Castello the ground rises in terraces, enclosed in lateral walls, to a high retaining-wall at the back, surmounted by a wood of ilexes which contains a pool with an island. Montaigne, who describes but few gardens in his Italian diary, mentions that the terraces of Castello are *en pante* (sic); that is, they incline gradually toward the house, with the slope of the ground. This bold and unusual adaptation of formal gardening to the natural exigencies of the site is also seen in the terraced gardens of the beautiful Villa Imperiali (now Scassi) at Sampierdarena, near Genoa. The plan of the garden at Castello is admirable, but in detail it has been modernized at the cost of all its charm. Wide steps lead up to the first terrace, where Il Tribolo's stately fountain of bronze and marble stands surrounded

by marble benches and statues on fine rusticated pedestals. Unhappily, fountain and statues have lately been scrubbed to preternatural whiteness, and the same spirit of improvement has turned the old parterres into sunburnt turf, and dotted it with copper beeches and pampas-grass. Montaigne alludes to the *berceaux*, or pleached walks, and to the close-set cypresses which made a delicious coolness in this garden; and as one looks across its sun-scorched expanse one perceives that its lack of charm is explained by lack of shade.

As is usual in Italian gardens built against a hillside, the retaining-wall at the back serves for the great decorative motive at Castello. It is reached by wide marble steps, and flanked at the sides by symmetrical lemon-houses. On the central axis of the garden, the wall has a wide opening between columns, and on each side an arched recess, equidistant between the lemon-houses and the central opening. Within the latter is one of those huge grottoes[1] which for two centuries or more were the delight of Italian garden-architects. The roof is decorated with masks and arabesques in coloured shell-work, and in the niches of the tufa of which the background is formed are strange groups of life-sized animals, a camel, a monkey, a stag with real antlers, a wild boar with real tusks, and various small animals and birds, some made of coloured marbles which correspond with their natural tints; while beneath these

[1] This grotto and its sculptures are the work of Il Tribolo, who also built the aqueduct bringing thither the waters of the Arno and the Mugnone.

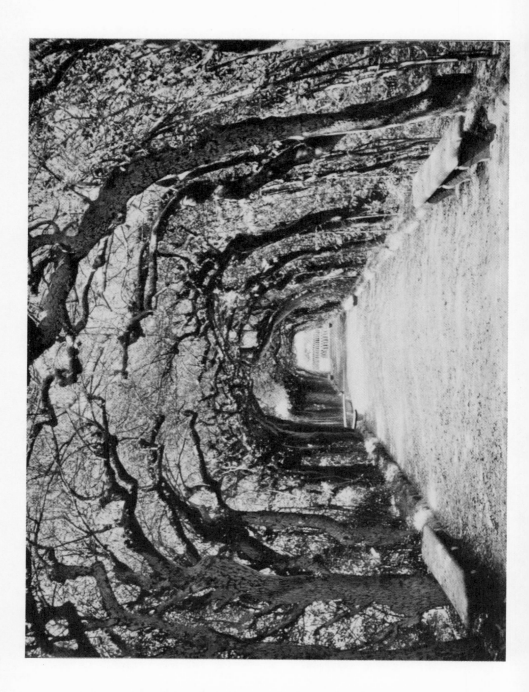

ILEX-WALK, BOBOLI GARDEN, FLORENCE

groups are basins of pink-and-white marble, carved with sea-creatures and resting on dolphins. Humour is the quality which soonest loses its savour, and it is often difficult to understand the grotesque side of the old garden-architecture; but the curious delight in the representations of animals, real or fantastic, probably arose from the general interest in those strange wild beasts of which the travellers of the Renaissance brought home such fabulous descriptions. As to the general use of the grotto in Italian gardens, it is a natural development of the need for shade and coolness, and when the long-disused waterworks were playing, and cool streams gushed over quivering beds of fern into the marble tanks, these retreats must have formed a delicious contrast to the outer glare of the garden.

At Petraia the gardens are less elaborate in plan than at Castello, and are, in fact, noted chiefly for a fountain brought from that villa. This fountain, the most beautiful of Il Tribolo's works, is surmounted by the famous Venus-like figure of a woman wringing out her hair, now generally attributed to Giovanni da Bologna. Like the other Florentine villas of this quarter, where water is more abundant, Petraia has a great oblong *vasca*, or tank, beneath its upper terrace; while the house itself, a simple structure of the old-fashioned Tuscan type, built about an inner quadrangle, is remarkable for its very beautiful tower, which, as Herr Gurlitt[1] suggests, was doubtless inspired by the tower of the Palazzo Vecchio.

[1] " Geschichte des Barockstils in Italien."

According to Zocchi's charming etching, the ducal villa of Poggio Imperiale, on a hillside to the south of Florence, still preserved, in the eighteenth century, its simple and characteristic Tuscan façade. This was concealed by the Grand Duke Peter Leopold behind a heavy pillared front, to which the rusticated porticoes were added later; and externally nothing remains as it was save the ilex and cypress avenue, now a public highway, which ascends to the villa from the Porta Romana, and the semicircular entrance-court with its guardian statues on mighty pedestals.

Poggio Imperiale was for too long the favourite residence of the grand-ducal Medici, and of their successors of Lorraine, not to suffer many changes, and to lose, one by one, all its most typical features. Within there is a fine court surrounded by an open arcade, probably due to Giulio Parigi, who, at the end of the sixteenth century, completed the alterations of the villa according to the plans of Giuliano da Sangallo; and the vast suites of rooms are interesting to the student of decoration, since they are adorned, probably by French artists, with exquisite carvings and *stucchi* of the Louis XV and Louis XVI periods. But the grounds have kept little besides their general plan. At the back, the villa opens directly on a large level pleasure-garden, with enclosing walls and a central basin surrounded by statues; but the geometrical parterres have been turned into a lawn. To the right of this level space, a few steps lead down

to a long terrace planted with ilexes, whence there is a fine view over Florence—an unusual arrangement, as the *bosco* was generally above, not below, the flower-garden.

If, owing to circumstances, the more famous pleasure-grounds of Florence have lost much of their antique charm, she has happily preserved a garden of another sort which possesses to an unusual degree the flavour of the past. This is the villa of the Gamberaia at Settignano. Till its recent purchase, the Gamberaia had for many years been let out in lodgings for the summer, and it doubtless owes to this obscure fate the complete preservation of its garden-plan. Before the recent alterations made in its gardens, it was doubly interesting from its unchanged condition, and from the fact that, even in Italy, where small and irregular pieces of ground were so often utilized with marvellous skill, it was probably the most perfect example of the art of producing a great effect on a small scale.

The villa stands nobly on a ridge overlooking the village of Settignano and the wide-spread valley of the Arno. The house is small yet impressive. Though presumably built as late as 1610, it shows few concessions to the baroque style already prevalent in other parts of Italy, and is yet equally removed from the classic or Palladian manner which held its own so long in the Venetian country. The Gamberaia is distinctly Tuscan, and its projecting eaves, heavily coigned angles

and windows set far apart on massive consoles, show its direct descent from the severe and sober school of six-teenth-century architects who produced such noble examples of the great Tuscan villa as I Collazzi and Fonte all' Erta. Nevertheless, so well proportioned is its elevation that there is no sense of heaviness, and the solidity of the main building is relieved by a kind of flying arcade at each end, one of which connects the house with its chapel, while the other, by means of a spiral stairway in a pier of the arcade, leads from the first floor to what was once the old fish-pond and herb-garden. This garden, an oblong piece of ground, a few years ago had in its centre a round fish-pond, sur-rounded by symmetrical plots planted with roses and vegetables, and in general design had probably been little changed since the construction of the villa. It has now been remodelled on an elaborate plan, which has the disadvantage of being unrelated in style to its surround-ings; but fortunately no other change has been made in the plan and planting of the grounds.

Before the façade of the house a grassy terrace bounded by a low wall, set alternately with stone vases and solemn-looking stone dogs, overhangs the vine-yards and fields, which, as in all unaltered Tuscan country places, come up close to the house. Behind the villa, and running parallel with it, is a long grass alley or bowling-green, flanked for part of its length by a lofty retaining-wall set with statues, and for the

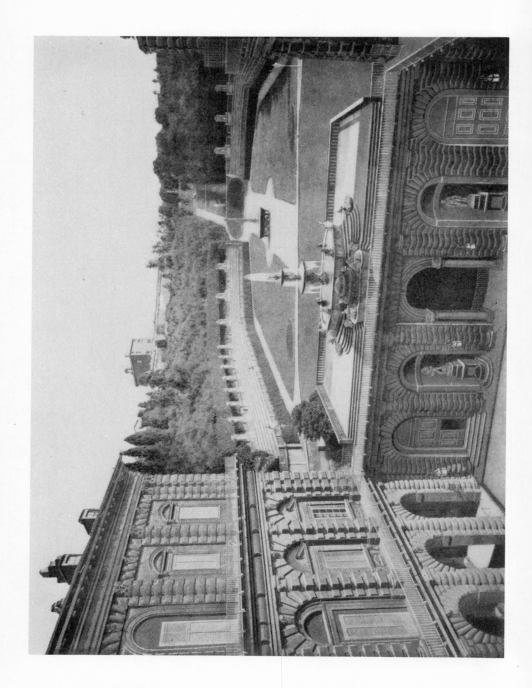

VIEW OF AMPHITHEATRE, BOBOLI GARDEN, FLORENCE

remainder by high hedges which divide it on one side from the fish-pond garden and on the other from the farm. The green is closed at one end by a grotto of coloured pebbles and shells, with nymphs and shepherds in niches about a fountain. This grotto is overhung by the grove of ancient cypresses for which the Gamberaia is noted. At its opposite end the bowling-green terminates in a balustrade whence one looks down on the Arno and across to the hills on the southern side of the valley.

The retaining-wall which runs parallel with the back of the house sustains a terrace planted with cypress and ilex. This terraced wood above the house is very typical of Italian gardens: good examples may be seen at Castello and at the Villa Medici in Rome. These patches of shade, however small, are planted irregularly, like a wild wood, with stone seats under the dense ilex boughs, and a statue placed here and there in a deep niche of foliage. Just opposite the central doorway of the house the retaining-wall is broken, and an iron gate leads to a slit of a garden, hardly more than twenty feet wide, on a level with the bowling-green. This narrow strip ends also in a grotto-like fountain with statues, and on each side balustraded flights of steps lead to the upper level on which the ilex-grove is planted. This grove, however, occupies only one portion of the terrace. On the other side of the cleft formed by the little grotto-garden, the corresponding terrace, formerly laid out as

a vegetable-garden, is backed by the low façade of the lemon-house, or *stanzone*, which is an adjunct of every Italian villa. Here the lemon and orange trees, the camellias and other semi-tender shrubs, are stored in winter, to be set out in May in their red earthen jars on the stone slabs which border the walks of all old Italian gardens.

The plan of the Gamberaia has been described thus in detail because it combines in an astonishingly small space, yet without the least sense of overcrowding, almost every typical excellence of the old Italian garden: free circulation of sunlight and air about the house; abundance of water; easy access to dense shade; sheltered walks with different points of view; variety of effect produced by the skilful use of different levels; and, finally, breadth and simplicity of composition.

Here, also, may be noted in its fullest expression that principle of old gardening which the modern "landscapist" has most completely unlearned, namely, the value of subdivision of spaces. Whereas the modern gardener's one idea of producing an effect of space is to annihilate his boundaries, and not only to merge into one another the necessary divisions of the garden, but also to blend this vague whole with the landscape, the old garden-architect proceeded on the opposite principle, arguing that, as the garden is but the prolongation of the house, and as a house containing a single huge room would be less interesting and less serviceable than

one divided according to the varied requirements of its inmates, so a garden which is merely one huge outdoor room is also less interesting and less serviceable than one which has its logical divisions. Utility was doubtless not the only consideration which produced this careful portioning off of the garden. Æsthetic impressions were considered, and the effect of passing from the sunny fruit-garden to the dense grove, thence to the wide-reaching view, and again to the sheltered privacy of the pleached walk or the mossy coolness of the grotto—all this was taken into account by a race of artists who studied the contrast of æsthetic emotions as keenly as they did the juxtaposition of dark cypress and pale lemon-tree, of deep shade and level sunlight. But the real value of the old Italian garden-plan is that logic and beauty meet in it, as they should in all sound architectural work. Each quarter of the garden was placed where convenience required, and was made accessible from all the others by the most direct and rational means; and from this intelligent method of planning the most varying effects of unexpectedness and beauty were obtained.

It was said above that lawns are unsuited to the Italian soil and climate, but it must not be thought that the Italian gardeners did not appreciate the value of turf. They used it, but sparingly, knowing that it required great care and was not a characteristic of the soil. The bowling-green of the Gamberaia shows how

well the beauty of a long stretch of greensward was understood; and at the Villa Capponi, at Arcetri, on the other side of Florence, there is a fine oblong of old turf adjoining the house, said to be the only surviving fragment of the original garden. These bits of sward were always used near the house, where their full value could be enjoyed, and were set like jewels in clipped hedges or statue-crowned walls. Though doubtless intended chiefly for games, they were certainly valued for their æsthetic effect, for in many Italian gardens steep grass alleys flanked by walls of beech or ilex are seen ascending a hillside to the temple or statue which forms the crowning ornament of the grounds. In Florence a good example of this *tapis vert*, of which Le Nôtre afterward made such admirable use in the moist climate of France, is seen at the Villa Danti, on the Arno near Campiobbi.

Close to the ducal villas of Castello lies a country-seat possessing much of the intimate charm which they lack. This is Prince Corsini's villa, the finest example of a baroque country house near Florence. The old villa, of which the typical Tuscan elevation may still be seen at the back, was remodelled during the latter half of the seventeenth century, probably by Antonio Ferri, who built the state saloon and staircase of the Palazzo Corsini on the Lungarno. The Villa Corsini lies in the plain, like Castello, and has before it the usual walled semicircle. The front of the villa is frankly baroque, a

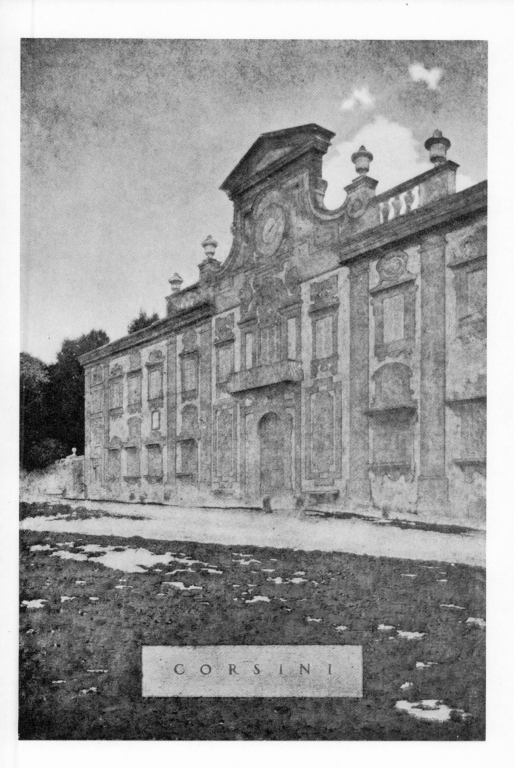

VILLA CORSINI, FLORENCE

two-storied elevation with windows divided by a meagre order, and a stately central gable flanked by balustrades surmounted by vases. The whole treatment is interesting, as showing the manner in which the seventeenth-century architect overlaid a plain Tuscan structure with florid ornament; and the effect, if open to criticism, is at once gay and stately.

The house is built about a quadrangle enclosed in an open arcade on columns. Opposite the porte-cochère is a doorway opening on a broad space bounded by a balustrade with statues. An ilex avenue extends beyond this space, on the axis of the doorway. At one end of the house is the oblong walled garden, with its box-edged flower-beds grouped in an intricate geometrical pattern about a central fountain. Corresponding with this garden, at the opposite end of the house, is a dense ilex-grove with an alley leading down the centre to a beautiful fountain, a tank surmounted by a kind of voluted pediment, into which the water falls from a large ilex-shaded tank on a higher level. Here again the vineyards and olive-orchards come up close to the formal grounds, the ilex-grove being divided from the *podere* by a line of cypresses instead of a wall.

Not far from the Gamberaia, on the hillside of San Gervasio, stands another country house which preserves only faint traces of its old gardens, but which, architecturally, is too interesting to be overlooked. This is the villa of Fonte all' Erta. Originally a long building of

the villa-farmhouse order, with chapel, offices and out-houses connected with the main house, it was trans-formed in the sixteenth century, probably by Ammanati, into one of the stateliest country houses near Florence. A splendid rusticated loggia, approached by a double flight of steps, forms an angle of the main house, and either then or later the spacious open court, around three sides of which the villa is built, was roofed over and turned into a great central saloon like those of the Venetian and Milanese villas. This two-storied saloon is the finest and most appropriate feature of the interior planning of Italian villas, but it seems never to have been as popular in Tuscany as it was farther north or south. The Tuscan villas, for the most part, are smaller and less pretentious in style than those erected in other parts of Italy, and only in exceptional instances did the architect free himself from the traditional plan of the old farmhouse-villa around its open court. A fine example of this arcaded court may be seen at Petraia, the Medi-cean villa near Castello. At Fonte all' Erta the former court faced toward what was once an old flower-garden, raised a few feet above the grass terrace which runs the length of the façade. Behind this garden, and adjoining the back of the villa, is the old evergreen grove; but the formal surroundings of the house have disappeared.

The most splendid and stately villa in the neighbour-hood of Florence stands among the hills a few miles

beyond the Certosa of Val d'Ema, and looks from its lofty ridge across the plain toward Pistoia and the Apennines. This villa, called Ai Collazzi (now Bombicci), from the wooded hills which surround it, was built for the Dini family in the sixteenth century, and, as tradition avers, by no less a hand than Michelangelo's. He is known to have been a close friend of the Dini, and is likely to have worked for them; and if, as some experts think, certain details of the design, as well as the actual construction of the villa, are due to Santi di Tito, it is impossible not to feel that its general conception must have originated with a greater artist.

The Villa Bombicci has in fact the Michelangelesque quality: the austerity, the breadth, the peculiar majesty which he imparted to his slightest creations. The house is built about three sides of a raised stone-flagged terrace, the enclosing elevation consisting of a two-storied open arcade roofed by widely projecting eaves. The wings are solid, with the exception of the sides toward the arcade, and the windows, with their heavy pediments and consoles, are set far apart in true Tuscan fashion. A majestic double flight of steps, flanked by shield-bearing lions, leads up to the terrace about which the house is built. Within is a high central saloon opening at the back on a stone *perron*, with another double flight of steps which descend in a curve to the garden. On this side of the house there is, on the upper floor, an open loggia of great beauty, consisting of three

arches divided by slender coupled shafts. Very fine, also, is the arched and rusticated doorway surmounted by a stone escutcheon.

The villa is approached by a cypress avenue which leads straight to the open space before the house. The ridge on which the latter is built is so narrow, and the land falls away so rapidly, that there could never have been much opportunity for the development of garden-architecture; but though all is now Anglicized, it is easy to trace the original plan: in front, the open space supported by a high retaining-wall, on one side of the house the grove of cypress and ilex, and at the back, where there was complete privacy, the small *giardino segreto*, or hedged garden, with its parterres, benches and statues.

The purpose of this book is to describe the Italian villa in relation to its grounds, and many villas which have lost their old surroundings must therefore be omitted; but near Florence there is one old garden which has always lacked its villa, yet which cannot be overlooked in a study of Italian garden-craft. Even those most familiar with the fascinations of Italian gardens will associate a peculiar thrill with their first sight of the Villa[1] Campi. Laid out by one of the Pucci family, probably toward the end of the sixteenth century, it lies beyond Lastra-Signa, above the Arno, about

[1] *Villa*, in Italian, signifies not the house alone, but the house and pleasure-grounds.

ten miles from Florence. It is not easy to reach, for so long is it since any one has lived in the melancholy *villino* of Villa Campi that even in the streets of Lastra, the little walled town by the Arno, a guide is hard to find. But at last one is told to follow a steep country road among vines and olives, past two or three charming houses buried in ilex-groves, till the way ends in a lane which leads up to a gateway surmounted by statues. Ascending thence by a long avenue of cypresses, one reaches the level hilltop on which the house should have stood. Two pavilions connected by a high wall face the broad open terrace, whence there is a far-spreading view over the Arno valley: doubtless the main building was to have been placed between them. But now the place lies enveloped in a mysterious silence. The foot falls noiselessly on the grass carpeting of the alleys, the water is hushed in pools and fountains, and broken statues peer out startlingly from their niches of unclipped foliage. From the open space in front of the pavilions, long avenues radiate, descending and encircling the hillside, walled with cypress and ilex, and leading to *rond-points* set with groups of statuary, and to balus-traded terraces overhanging the valley. The plan is vast and complicated, and appears to have embraced the whole hillside, which, contrary to the usual frugal Tuscan plan, was to have been converted into a formal park with vistas, quincunxes and fountains.

Entering a gate in the wall between the pavilions,

one comes on the terraced flower-gardens, and here the same grandeur of conception is seen. The upper terrace preserves traces of its formal parterres and box-hedges. Thence flights of steps lead down to a long bowling-green between hedges, like that at the Gamberaia. A farther descent reveals another terrace-garden, with clipped hedges, statues and fountains; and thence sloping alleys radiate down to stone-edged pools with reclining river-gods in the mysterious shade of the ilex-groves. Statues are everywhere: in the upper gardens, nymphs, satyrs, shepherds, and the cheerful fauna of the open pleasance; at the end of the shadowy glades, solemn figures of Titanic gods, couched above their pools or reared aloft on mighty pedestals. Even the opposite hillside must have been included in the original scheme of this vast garden, for it still shows, on the central axis between the pavilions, a *tapis vert* between cypresses, doubtless intended to lead up to some great stone Hercules under a crowning arch.

But it is not the size of the Campi gardens which makes them so remarkable; it is the subtle beauty of their planning, to which time and neglect have added the requisite touch of poetry. Never perhaps have natural advantages been utilized with so little perceptible straining after effect, yet with so complete a sense of the needful adjustment between landscape and architecture. One feels that these long avenues and statued terraces were meant to lead up to a " stately pleasure-house ";

yet so little are they out of harmony with the surrounding scene that nature has gradually taken them back to herself, has turned them into a haunted grove in which the statues seem like sylvan gods fallen asleep in their native shade.

There are other Florentine villas which preserve traces of their old gardens. The beautiful Villa Palmieri has kept its terrace-architecture, Lappeggi its fine double stairway, the Villa Danti its grass-walk leading to a giant on the hilltop, and Castel Pulci its stately façade with a sky-line of statues and the long cypress avenue shown in Zocchi's print; even Pratolino, so cruelly devastated, still preserves Giovanni da Bologna's colossal figure of the Apennines. But where so much of greater value remains to be described, space fails to linger over these fragments which, romantic and charming as they are, can but faintly suggest, amid their altered surroundings, the vanished garden-plans of which they formed a part.

SIENESE VILLAS

SIENESE VILLAS

I N the order of age, the first country-seat near Siena which claims attention is the fortress-villa of Belcaro.

Frequent mention is made of the castle of Belcaro in early chronicles and documents, and it seems to have been a place of some importance as far back as the eleventh century. It stands on a hilltop clothed with oak and ilex in the beautiful wooded country to the west of Siena, and from its ancient walls one looks forth over the plain to the hill-set city and its distant circle of mountains. It was perhaps for the sake of this enchanting prospect that Baldassare Peruzzi, to whom the transformation of Belcaro is ascribed, left these crenellated walls untouched, and contented himself with adorning the inner court of the castle with a delicate mask of Renaissance architecture. A large bare villa of no architectural pretensions was added to the mediæval buildings, and Peruzzi worked within the enclosed quadrangle thus formed.

A handsome architectural screen of brick and marble with a central gateway leads from a stone-paved court

to a garden of about the same dimensions, at the back of which is an arcaded loggia, also of brick and marble, exquisitely light and graceful in proportion, and frescoed in the Raphaelesque manner with medallions and arabesques, fruit-garlands and brightly plumed birds. Adjoining this loggia is a small brick chapel, simple but elegant in design, with a frescoed interior also ascribed to Peruzzi, and still beautiful under its crude repainting. The garden itself is the real *hortus inclusus* of the mediæval chronicler: a small patch of ground enclosed in the fortress walls, with box-edged plots, a central well and clipped shrubs. It is interesting as a reminder of what the mediæval garden within the castle must have been, and its setting of Renaissance architecture makes it look like one of those little marble-walled pleasances, full of fruit and flowers, in the backgrounds of Gozzoli or Lorenzo di Credi.

Several miles beyond Belcaro, in a pleasant valley among oak-wooded hills, lies the Marchese Chigi's estate of Cetinale. A huge clipped ilex, one of the few examples of Dutch topiary work in Italy, stands at the angle of the road which leads to the gates. Across the highway, facing the courtyard entrance, is another gate, guarded by statues and leading to a long *tapis vert* which ascends between double rows of square-topped ilexes to a statue on the crest of the opposite slope. The villa looks out on this perspective, facing it across an oblong courtyard flanked by low outbuildings. The

main house, said to have been built (or more probably rebuilt) in 1680 by Carlo Fontana for Flavio Chigi, nephew of Pope Alexander VII, is so small and modest of aspect that one is surprised to learn that it was one of the celebrated pleasure-houses of its day. It must be remembered, however, that with the exception of the great houses built near Rome by the Princes of the Church, and the country-seats of such reigning families as the Medici, the Italian villa was almost invariably a small and simple building, the noble proprietor having usually preferred to devote his wealth and time to the embellishment of his gardens.

The house at Cetinale is so charming, with its stately double flight of steps leading up to the first floor, and its monumental doorway opening on a central *salone*, that it may well be ascribed to the architect of San Marcello in Rome, and of Prince Lichtenstein's "Garden Palace" in Vienna. The plan of using the low-studded ground floor for offices, wine-cellar and store-rooms, while the living-rooms are all above-stairs, shows the hand of an architect trained in the Roman school. All the Tuscan and mid-Italian villas open on a level with their gardens, while about Rome the country houses, at least on one side, have beneath the living-rooms a ground floor generally used for the storage of wine and oil.

But the glory of Cetinale is its park. Behind the villa a long grass-walk as wide as the house extends between high walls to a fantastic gateway, with statues

in ivy-clad niches, and a curious crowning motive ter-
minating in obelisks and balls. Beyond this the turf-
walk continues again to a raised semicircular terrace,
surrounded by a wall adorned with busts and enclosed
in clipped ilexes. This terrace abuts on the ilex-clothed
hillside which bounds the valley. A gateway leads
directly into these wild romantic woods, and a steep
irregular flight of stone steps is seen ascending the
wooded slope to a tiny building on the crest of the hill.
This ascent is called the Scala Santa, and the building
to which it leads is a hermitage adorned with circular
niches set in the form of a cross, each niche containing
the bust of a saint. The hermitage being directly on
the axis of the villa, one looks out from the latter down
the admirable perspective of the *tapis vert* and up the
Scala Santa to the little house at its summit. It is inter-
esting to note that this effect of distance and grandeur
is produced at small cost and in the simplest manner;
for the grass-walk with its semicircular end forms the
whole extent of the Cetinale garden. The olive-orchards
and corn-fields of the farm come up to the boundary
walls of the walk, and the wood is left as nature planted
it. Fontana, if it was indeed he who laid out this simple
but admirable plan, was wise enough to profit by the
natural advantage of the great forest of oak and ilex
which clothes this part of the country, and to realize
that only the broadest and simplest lines would be in
harmony with so noble a background.

As charming in its way, though less romantic and original, is the Marchese Chigi's other seat of Vicobello, a mile or two beyond the Porta Ovile, on the other side of Siena. Vicobello lies in an open villa-studded country in complete contrast to the wooded hills about Cetinale. The villa is placed on a long narrow ridge of land, falling away abruptly at the back and front. A straight entrance avenue runs parallel to the outer walls of the outbuildings, which form the boundary of the court, the latter being entered through a vaulted porte-cochère. Facing this entrance (as at Cetinale) is a handsome gateway guarded by statues and set in a semicircular wall. Passing through this gate, one descends to a series of terraces planted with straight rows of the square-topped ilexes so characteristic of the Sienese gardens. These densely shaded terraces descend to a level stretch of sward (perhaps an old bowling-green) bordered by a wall of clipped ilexes, at the foot of the hill on which the villa stands.

On entering the forecourt, one faces the villa, a dignified oblong building of simple Renaissance architecture, ascribed in the local guide-book to Baldassare Peruzzi, and certainly of earlier construction than the house at Cetinale. On the left, a gate in a high wall leads to a walled garden, bounded by a long lemon-house which continues the line of the outbuildings on the court. Opposite, a corresponding gateway opens into the *bosco* which is the indispensable adjunct of the

69

Italian country house. On the other side of the villa are two long terraces, one beneath the other, corresponding in dimensions with the court, and flanked on each hand by walled terrace-gardens, descending on one side from the grove, on the other from the upper garden adjoining the court. The plan, which is as elaborate and minutely divided as that of Cetinale is spacious and simple, shows an equally sure appreciation of natural conditions, and of the distinction between a *villa suburbana* and a country estate. The walls of the upper garden are espaliered with fruit-trees, and the box-edged flower-plots are probably laid out much as they were in the eighteenth century. All the architectural details are beautiful, especially a well in the court, set in the wall between Ionic columns, and a charming garden-house at the end of the upper garden, in the form of an open archway faced with Doric pilasters, before a semicircular recess with a marble seat. The descending walled gardens, with their different levels, give opportunity for many charming architectural effects — busts in niches, curving steps, and well-placed vases and statues; and the whole treatment of Vicobello is remarkable for the discretion and sureness of taste with which these ornamental touches are added. There is no excess of decoration, no crowding of effects, and the garden-plan is in perfect keeping with the simple stateliness of the house.

About a mile from Vicobello, on an olive-clad hillside

near the famous monastery of the Osservanza, lies another villa of much more modest dimensions, with grounds which, though in some respects typically Sienese, are in one way unique in Italy. This is La Palazzina, the estate of the De' Gori family. The small seventeenth-century house, with its adjoining chapel and outbuildings, lies directly on the public road, and forms the boundary of its own grounds. The charming garden-façade, with its voluted sky-line, and the two-storied open loggia forming the central motive of the elevation, faces on a terrace-like open space, bounded by a wall, and now irregularly planted *à l'Anglaise*, but doubtless once the site of the old flower-garden. Before the house stands an old well with a beautiful wrought-iron railing, and on the axis of the central loggia a gate opens into one of the pleached ilex-alleys which are the glory of the Palazzina. This ancient tunnel of gnarled and interlocked trees, where a green twilight reigns in the hottest summer noon, extends for several hundred feet along a ridge of ground ending in a sort of circular knoll or platform, surrounded by an impenetrable wall of square-clipped ilexes. The platform has in its centre a round clearing, from which four narrow paths radiate at right angles, one abutting on the pleached walk, the others on the outer ilex-wall. Between these paths are four small circular spaces planted with stunted ilexes and cypresses, which are cut down to the height of shrubs.

In these dwarf trees blinded thrushes are tied as decoys to their wild kin, who are shot at from the circular clearing or the side paths. This elaborate plantation is a perfectly preserved specimen of a species of bird-trap once, alas! very common in this part of Italy, and in which one may picture the young gallants of Folgore da San Gimignano's Sienese sonnets "Of the Months" taking their cruel pleasure on an autumn day.

Another antique alley of pleached ilexes, as densely shaded but not quite as long, runs from the end of the terrace to a small open-air theatre which is the greatest curiosity of the Villa de' Gori. The pit of this theatre is a semicircular opening, bounded by a low wall or seat, which is backed by a high ilex-hedge. The parterre is laid out in an elaborate *broderie* of turf and gravel, above which the stage is raised about three feet. The pit and the stage are enclosed in a double hedge of ilex, so that the actors may reach the wings without being seen by the audience; but the stage-setting consists of rows of clipped cypresses, each advancing a few feet beyond the one before it, so that they form a perspective running up to the back of the stage, and terminated by the tall shaft of a single cypress which towers high into the blue in the exact centre of the background. No mere description of its plan can convey the charm of this exquisite little theatre, approached through the mysterious dusk of the long pleached alley, and lying in sunshine and silence under its roof of blue sky, in its walls of

unchanging verdure. Imagination must people the stage with the sylvan figures of the *Aminta* or the *Pastor Fido*, and must place on the encircling seats a company of *nobil donne* in pearls and satin, with their cavaliers in the black Spanish habit and falling lace collar which Vandyke has immortalized in his Genoese portraits; and the remembrance of this leafy stage will lend new life to the reading of the Italian pastorals, and throw a brighter sunlight over the woodland comedies of Shakspeare.

ROMAN VILLAS

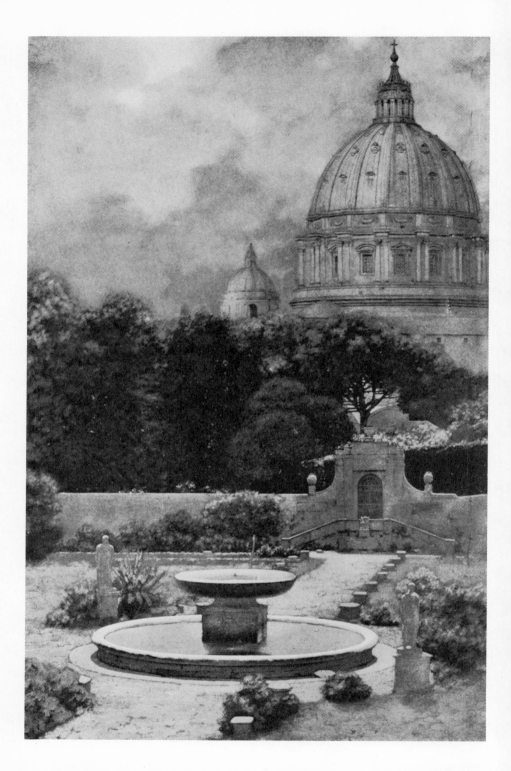

THE DOME OF ST. PETER'S, FROM THE VATICAN GARDENS

III

ROMAN VILLAS

I N studying the villas near the smaller Italian towns, it is difficult to learn much of their history. Now and then some information may be gleaned from a local guide-book, but the facts are usually meagre or inaccurate, and the name of the architect, the date of the building, the original plan of the garden, have often alike been forgotten.

With regard to the villas in and about Rome, the case is different. Here the student is overwhelmed by a profusion of documents. Illustrious architects dispute the honour of having built the famous pleasure-houses on the seven hills, and historians of art, from Vasari downward, have recorded their annals. Falda engraved them in the seventeenth century, and Percier and Fontaine at the beginning of the nineteenth; and they have been visited and described, at various periods, by countless travellers from different countries.

One of the earliest Roman gardens of which a description has been preserved is that which Bramante laid out within the Vatican in the last years of the fifteenth century. This terraced garden, with its monumental

double flight of steps leading up by three levels to the Giardino della Pigna, was described in 1523 by the Venetian ambassador to Rome, who speaks of its grass parterres and fountains, its hedges of laurel and cypress, its plantations of mulberries and roses. One half of the garden (the court of the Belvedere) had brick-paved walks between rows of orange-trees; in its centre were statues of the Nile and the Tiber above a fountain; while the Apollo, the Laocoon and the Venus of the Vatican were placed about it in niches. This garden was long since sacrificed to the building of the Braccio Nuovo and the Vatican Library; but it is worth mentioning that Burckhardt, whose least word on Italian gardens is more illuminating than the treatises of other writers, thought that Bramante's terraced stairway first set the example of that architectural magnificence which marks the great Roman gardens of the Renaissance.

Next in date comes the Villa Madama, Raphael's unfinished masterpiece on the slope of Monte Mario. This splendid pleasure-house, which was begun in 1516 for Cardinal Giuliano de' Medici, afterward Pope Clement VII, was intended to be the model of the great *villa suburbana*, and no subsequent building of the sort is comparable to what it would have been had the original plans been carried out. But the villa was built under an evil star. Raphael died before the work was finished, and it was carried on with some alterations by Giulio Romano and Antonio da Sangallo. In 1527 the troops

of Cardinal Colonna nearly destroyed it by fire; and, without ever being completed, it passed successively into the possession of the Chapter of St. Eustace, of the Duchess of Parma (whence its name of *Madama*), and of the King of Naples, who suffered it to fall into complete neglect.

The unfinished building, with its mighty loggia stuccoed by Giovanni da Udine, and the semicircular arcade at the back, is too familiar to need detailed description; and the gardens are so dilapidated that they are of interest only to an eye experienced enough to reconstruct them from their skeleton. They consist of two long terraces, one above the other, cut in the side of the wooded slope overhanging the villa. The upper terrace is on a level with Raphael's splendid loggia, and seems but a roofless continuation of that airy hall. Against the hillside and at the end it is bounded by a retaining-wall once surmounted by a marble balustrade and set with niches for statuary, while on the other side it looks forth over the Tiber and the Campagna. Below this terrace is another of the same proportions, its retaining-wall broken at each end by a stairway descending from the upper level, and the greater part of its surface taken up by a large rectangular tank, into which water gushes from the niches in the lateral wall. It is evident from the breadth of treatment of these terraces that they are but a fragment of the projected whole. Percier and Fontaine, in their " Maisons de Plaisance de Rome"

(1809), published an interesting "reconstitution" of the Villa Madama and its gardens, as they conceived it might have been carried to completion; but their plan is merely the brilliant conjecture of two artists penetrated with the spirit of the Renaissance, for they had no documents to go by. The existing fragment is, however, well worthy of study, for the purity of its architecture and the broad simplicity of its plan are in marked contrast to the complicated design and overcharged details of some of the later Roman gardens.

Third in date among the early Renaissance gardens comes another, of which few traces are left: that of the Vigna del Papa, or Villa di Papa Giulio, just beyond the Porta del Popolo. Here, however, the building itself, and the architectural composition which once united the house and grounds, are fortunately well preserved, and so exceptionally interesting that they deserved a careful description. The Villa di Papa Giulio was built by Pope Julius III, whose pontificate extends from 1550 to 1555. The villa therefore dates from the middle of the sixteenth century; but so many architects were associated with it, and so much confusion exists as to their respective contributions, that it can only be said that the Pope himself, Michelangelo, Vignola, Vasari and Ammanati appear all to have had a hand in the work. The exterior elevation, though it has been criticized, is not as inharmonious as might have been expected, and on the garden side both plan and elevation have a charm

and picturesqueness which disarm criticism. Above all, it is felt at once that the arrangement is perfectly suited to a warm climate. The villa forms a semicircle at the back, enclosing a paved court. The ground floor is an open vaulted arcade, adorned with Zucchero's celebrated frescoes of *putti* peeping through vine-wreathed trellises; and the sides of the court, beyond this arcade, are bounded by two-storied lateral wings, with blind arcades and niches adorned with statues. Facing the villa, a colonnaded loggia terminates the court; and thence one looks down into the beautiful lower court of the bath, which appears to have been designed by Vasari. From the loggia, steps descend to a semicircular court enclosed in walls, with a balustraded opening in its centre; and this balustrade rests on a row of caryatids which encircle the lowest court and form a screen before the grotto-like bath under the arches of the upper terrace. The plan is too complicated, and the architectural motives are too varied, to admit of clear description: both must be seen to give an idea of the full beauty of the composition. Returning to the upper loggia above the bath, one looks across the latter to a corresponding loggia of three arches on the opposite side, on the axis of which is a gateway leading to the actual gardens — gardens which, alas! no longer exist. It will thus be seen that the flagged court, the two open loggias, and the bath are so many skilfully graduated steps in what Percier and Fontaine call the "artistic progression" linking the gardens to the house,

while the whole is so planned that from the central hall of the villa (and in fact from its entrance-door) one may look across the court and down the long vista of columns, into what were once the shady depths of the garden.

In all Italian garden-architecture there is nothing quite comparable for charm and delicately reminiscent classicalism with this grotto-bath of Pope Julius's villa. Here we find the tradition of the old Roman villa-architecture, as it had been lovingly studied in the letters of Pliny, transposed. into Renaissance forms, with the sense of its continued fitness to unchanged conditions of climate and a conscious return to the splendour of the old patrician life. It is instructive to compare this natural reflowering of a national art with the frigid archæological classicalism of Winckelmann and Canova. Here there is no literal transcription of uncomprehended detail: the spirit is preserved, because it is still living, but it finds expression in subtly altered forms. Above all, the artist has drawn his inspiration from Roman art, the true source of modern architecture, and not from that of Greece, which, for all its beauty and far-reaching æsthetic influences, was *not* the starting-point of modern artistic conceptions, for the plain historical reason that it was utterly forgotten and unknown when the mediæval world began to wake from its lethargy and gather up its scattered heritage of artistic traditions.

When John Evelyn came to Rome in 1644 and

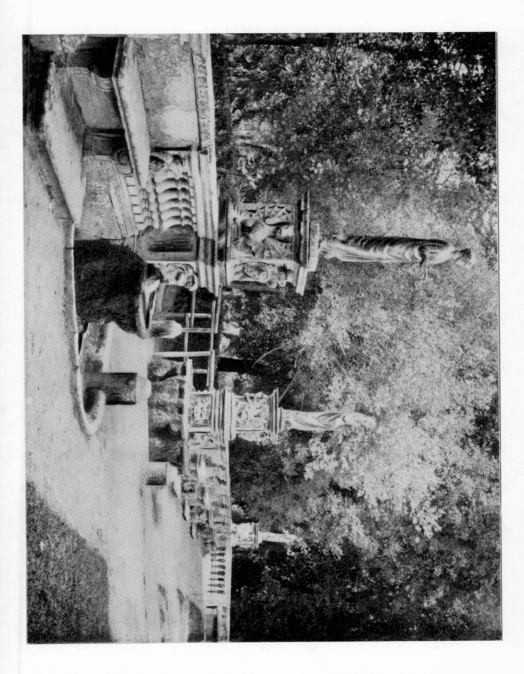

ENTRANCE TO FORECOURT, VILLA BORGHESE, ROME

alighted "at Monsieur Petit's in the Piazza Spagnola," many of the great Roman villas were still in the first freshness of their splendour, and the taste which called them forth had not yet wearied of them. Later travellers, with altered ideas, were not sufficiently interested to examine in detail what already seemed antiquated and out of fashion; but to Evelyn, a passionate lover of architecture and garden-craft, the Italian villas were patterns of excellence, to be carefully studied and minutely described for the benefit of those who sought to imitate them in England. It is doubtful if later generations will ever be diverted by the aquatic "surprises" and mechanical toys in which Evelyn took such simple pleasure; but the real beauties he discerned are once more receiving intelligent recognition after two centuries of contempt and indifference. It is worth noting in this connection that, at the very height of the reaction against Italian gardens, they were lovingly studied and truly understood by two men great enough to rise above the prejudices of their age: the French architects Percier and Fontaine, whose volume contains some of the most suggestive analyses ever written of the purpose and meaning of Renaissance garden-architecture.

Probably one of the least changed among the villas visited by Evelyn is "the house of the Duke of Florence upon the brow of Mons Pincius." The Villa Medici, on being sold by that family in 1801, had the

good fortune to pass into the hands of the French government, and its "facciata incrusted with antique and rare basso-relievos and statues" still looks out over the statued arcade, the terrace "balustraded with white marble" and planted with "perennial greens," and the "mount planted with cypresses," which Evelyn so justly admired.

The villa, built in the middle of the sixteenth century by Annibale Lippi, was begun for one cardinal and completed for another. It stands in true Italian fashion against the hillside above the Spanish Steps, its airy upper stories planted on one of the mighty bastion-like basements so characteristic of the Roman villa. A villa above, a fortress below, it shows that, even in the polished cinque-cento, life in the Papal States needed the protection of stout walls and heavily barred windows. The garden-façade, raised a story above the entrance, has all the smiling openness of the Renaissance pleasure-house, and is interesting as being probably the earliest example of the systematic use of fragments of antique sculpture in an architectural elevation. But this façade, with its charming central loggia, is sufficiently well known to make a detailed description superfluous, and it need be studied here only in relation to its surroundings.

Falda's plan of the grounds, and that of Percier and Fontaine, made over a hundred and fifty years later, show how little succeeding fashions have been allowed

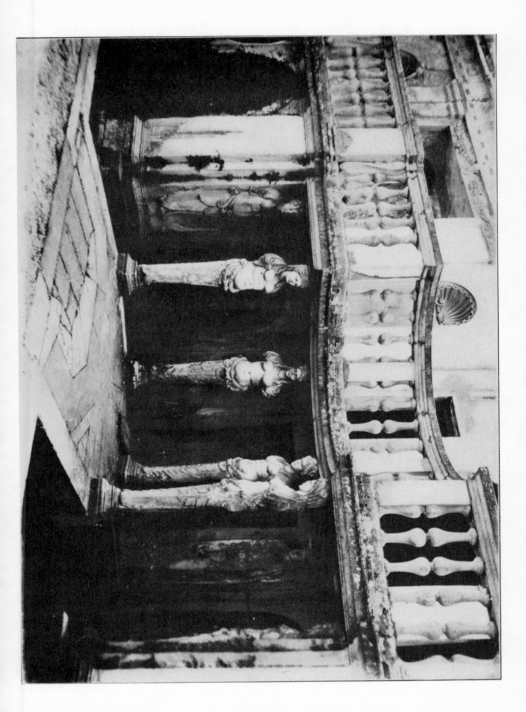

GROTTO, VILLA DI PAPA GIULIO, ROME

to disturb the original design. The gardens are still approached by a long shady alley which ascends from the piazza before the entrance; and they are still divided into a symmetrically planted grove, a flower-garden before the house, and an upper wild-wood with a straight path leading to the "mount planted with cypresses."

It is safe to say that no one enters the grounds of the Villa Medici without being soothed and charmed by that garden-magic which is the peculiar quality of some of the old Italian pleasances. It is not necessary to be a student of garden-architecture to feel the spell of quiet and serenity which falls on one at the very gateway; but it is worth the student's while to try to analyze the elements of which the sensation is composed. Perhaps they will be found to resolve themselves into diversity, simplicity and fitness. The plan of the garden is simple, but its different parts are so contrasted as to produce, by the fewest means, a pleasant sense of variety without sacrifice of repose. The ilex-grove into which one first enters is traversed by hedged alleys which lead to *rond-points* with stone seats and marble Terms. At one point the enclosing wall of ilex is broken to admit a charming open loggia, whence one looks into the depths of green below. Emerging from the straight shady walks, with their effect of uniformity and repose, one comes on the flower-garden before the house, spreading to the sunshine its box-edged parterres adorned with fountains

93

and statues. Here garden and house-front are harmonized by a strong predominance of architectural lines, and by the beautiful lateral loggia, with niches for statues, above which the upper ilex-wood rises. Tall hedges and trees there are none; for from the villa one looks across the garden at the wide sweep of the Campagna and the mountains; indeed, this is probably one of the first of the gardens which Gurlitt defines as "gardens to look out from," in contradistinction to the earlier sort, the "gardens to look into." Mounting to the terrace, one comes to the third division of the garden, the wild-wood with its irregular levels, through which a path leads to the mount, with a little temple on its summit. This is a rare feature in Italian grounds: in hilly Italy there was small need of creating the artificial hillocks so much esteemed in the old English gardens. In this case, however, the mount justifies its existence, for it affords a wonderful view over the other side of Rome and the Campagna.

Finally, the general impression of the Medici garden resolves itself into a sense of fitness, of perfect harmony between the material at hand and the use made of it. The architect has used his opportunities to the utmost; but he has adapted nature without distorting it. In some of the great French gardens, at Vaux and Versailles for example, one is conscious, under all the beauty, of the immense effort expended, of the vast upheavals of earth, the forced creating of effects; but it

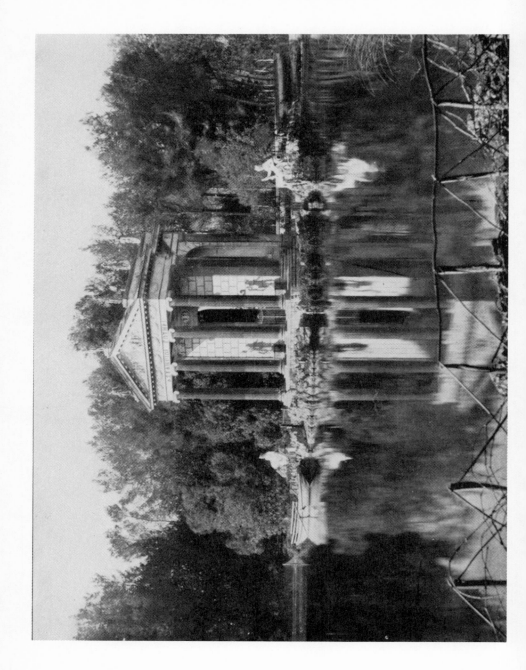

TEMPLE OF AESCULAPIUS, VILLA BORGHESE, ROME

was the great gift of the Italian gardener to see the natural advantages of his incomparable landscape, and to fit them into his scheme with an art which concealed itself.

While Annibale Lippi, an architect known by only two buildings, was laying out the Medici garden, the Palatine Hill was being clothed with monumental terraces by a master to whom the Italian Renaissance owed much of its stateliest architecture. Vignola, who transformed the slopes of the Palatine into the sumptuous Farnese gardens, was the architect of the mighty fortress-villa of Caprarola, and of the garden-portico of Mondragone; and tradition ascribes to him also the incomparable Lante gardens at Bagnaia.

In the Farnese gardens he found full play for his gift of grouping masses and for the scenic sense which enabled him to create such grandiose backgrounds for the magnificence of the great Roman prelates. The Palatine gardens have been gradually sacrificed to the excavations of the Palace of the Cæsars, but their almost theatrical magnificence is shown in the prints of Falda and of Percier and Fontaine. In this prodigal development of terraces, niches, porticoes and ramps, one perceives the outcome of Bramante's double staircase in the inner gardens of the Vatican, and Burckhardt justly remarks that in the Farnese gardens "the period of unity of composition and effective grouping of masses" finally triumphs over the earlier style.

No villa was ever built on this site, and there is consequently an air of heaviness and over-importance about the stately ascent which leads merely to two domed pavilions; but the composition would have regained its true value had it been crowned by such a palace as the Roman cardinals were beginning to erect for themselves. It is especially interesting to note the contrast in style and plan between this garden and that of the contemporaneous Villa Medici. One was designed for display, the other for privacy, and the success with which the purpose of each is fulfilled shows the originality and independence of their creators. It is a common error to think of the Italian gardens of the Renaissance as repeating endlessly the same architectural effects: their peculiar charm lies chiefly in the versatility with which their designers adapted them to different sites and different requirements.

As an example of this independence of meaningless conventions, let the student turn from the Villa Medici and the Orti Farnesiani to a third type of villa created at the same time—the Casino of Pope Pius IV in the Vatican gardens, built in 1560 by the Neapolitan architect Pirro Ligorio.

This exquisite little garden-house lies in a hollow of the outer Vatican gardens near the Via de' Fondamenti. A hillside once clothed with a grove rises abruptly behind it, and in this hillside a deep oblong cut has been made and faced with a retaining-wall. In the

space thus cleared the villa is built, some ten or fifteen feet away from the wall, so that its ground floor is cool and shaded without being damp. The building, which is long and narrow, runs lengthwise into the cut, its long façades being treated as sides, while it presents a narrow end as its front elevation. The propriety of this plan will be seen when the restricted surroundings are noted. In such a small space a larger structure would have been disproportionate; and Ligorio hit on the only means of giving to a house of considerable size the appearance of a mere garden-pavilion.

Percier and Fontaine say that Ligorio built the Villa Pia "after the manner of the ancient houses, of which he had made a special study." The influence of the Roman fresco-architecture is in fact visible in this delicious little building, but so freely modified by the personal taste of the architect that it has none of the rigidity of the "reconstitution," but seems rather the day-dream of an artist who has saturated his mind with the past.

The façade is a mere pretext for the display of the most exquisite and varied stucco ornamentation, in which motives borrowed from the Roman *stucchi* are harmonized with endless versatility. In spite of the wealth of detail, it is saved from heaviness and confusion by its delicacy of treatment and by a certain naïveté which makes it more akin (fantastic as the comparison may seem) with the stuccoed façade of San Bernardino at Perugia than with similar compositions of its own

9

period. The angels or genii in the oblong panels are curiously suggestive of Agostino da Duccio, and the pale-yellow tarnished surface of the stucco recalls the delicate hues of the Perugian chapel.

The ground floor consists of an open loggia of three arches on columns, forming a kind of atrium curiously

COURTYARD GATE OF THE VILLA PIA

faced with an elaborate mosaic-work of tiny round pebbles, stained in various colours and set in arabesques and other antique patterns. The coigns of the façade are formed of this same mosaic—a last touch of fancifulness where all is fantastic. The barrel-vault of the atrium is a marvel of delicate *stuc-cature*, evidently inspired by the work of Giovanni da Udine at the Villa Madama; and at each end stands a splendid marble basin resting on winged griffins. The fragile decorations of this exquisite loggia are open on three sides to the weather, and many windows of the upper rooms (which are decorated in the same style) are unshuttered and have broken panes, so that this unique example of cinque-cento decoration is gradually falling into ruin from mere exposure. The steps of the atrium,

flanked by marble Cupids on dolphins, lead to an oval paved court with a central fountain in which the Cupid-motive is repeated. This court is enclosed by a low wall with a seat running around it and surmounted by marble vases of a beautiful tazza-like shape. Facing the loggia, the wall is broken (as at the Villa di Papa Giulio) by a small pavilion resting on an open arcade, with an attic adorned with stucco panels; while at the sides, equidistant between the villa and the pavilion, are two vaulted porticoes, with façades like arches of triumph, by means of which access is obtained to curving ramps that lead to the lower level of the gardens. These porticoes are also richly adorned with stucco panels, and lined within with a mosaic-work of pebbles, forming niches for a row of busts.

From the central pavilion one looks down on a tank at its base (the pavilion being a story lower on its outer or garden side). This tank is surmounted by a statue of Thetis on a rock-work throne, in a niche formed in the basement of the pavilion. The tank encloses the pavilion on three sides, like a moat, and the water, gushing from three niches, overflows the low stone curb and drips on a paved walk slightly hollowed to receive it—a device producing a wonderful effect of coolness and superabundance of water.

The old gardens of the villa were on a level with the tank, and Falda's print shows the ingenuity of their planning. These gardens have now been almost entirely

destroyed, and the *bosco* above the villa has been cut down and replaced by bare grass-banks dotted with shrubs.

The Villa Pia has been thus minutely described, first, because it is seldom accessible, and consequently little known; but chiefly because it is virtually not a dwelling-house, but a garden-house, and thus forms a part of the actual composition of the garden. As such it stands alone in Italian architecture, and Burckhardt, who notes how well its lavish ornament is suited to a little pleasure-pavilion in a garden, is right in describing it as the "most perfect retreat imaginable for a midsummer afternoon."

The outer gardens of the Vatican, in a corner of which the Villa Pia lies, were probably laid out by Antonio da Sangallo the Younger, who died in 1546; and though much disfigured, they still show traces of their original plan. The sunny sheltered terrace, espaliered with lemons, is a good example of the "walk for the cold season" for which Italian garden-architects always provided; and the large sunken flower-garden surrounded by hanging woods is one of the earliest instances of this effective treatment of the *giardino segreto*. In fact, the Vatican may have suggested many features of the later Renaissance garden, with its wide-spread plan which gradually came to include the park.

The seventeenth century saw the development of this extended plan, but saw also the decline of the architec-

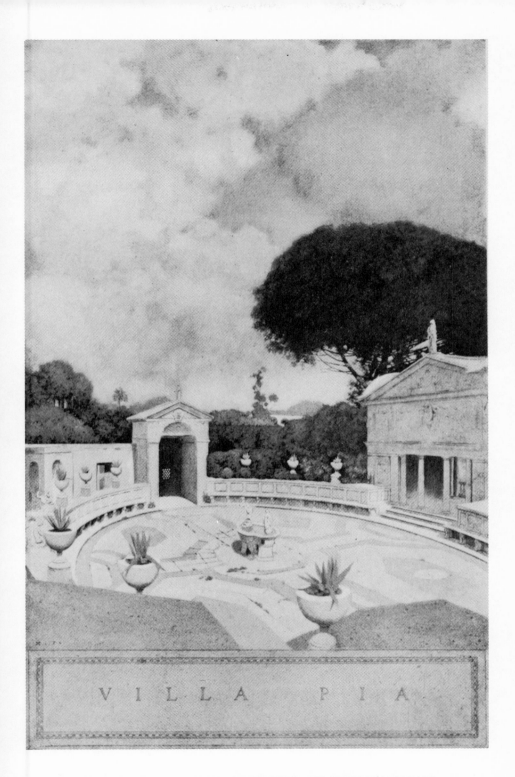

VILLA PIA—IN THE GARDENS OF THE VATICAN

tural restraint and purity of detail which mark the generation of Vignola and Sangallo. The Villa Borghese, built in 1618 by the Flemish architect Giovanni Vasanzia (John of Xanten), shows a complete departure from the old tradition. Its elevation may indeed be traced to the influence of the garden-front of the Villa Medici, which was probably the prototype of the gay pleasure-house in which ornamental detail superseded architectural composition; but the garden-architecture of the Villa Borghese, and the treatment of its extensive grounds, show the complete triumph of the baroque.

The grounds of the Villa Borghese, which include a park of several hundred acres, were laid out by Domenico Savino and Girolamo Rainaldi, while its water-works are due to Giovanni Fontana, whose name is associated with the great *jeux d'eaux* of the villas at Frascati. Falda's plan shows that the grounds about the house have been little changed. At each end of the villa is the oblong secret garden, not sunken but walled; in front an entrance-court, at the back an open space enclosed in a wall of clipped ilexes against which statues were set, and containing a central fountain. Beyond the left-hand walled garden are various dependencies, including an aviary. These little buildings, boldly baroque in style, surcharged with stucco ornament, and not without a certain Flemish heaviness of touch, have yet that gaiety, that *imprévu*, which was becoming the distinguishing note of Roman garden-architecture. On a

larger scale they would be oppressive; but as mere garden-houses, with their leafy background, and the picturesque adjuncts of high walls, wrought-iron gates, vases and statues, they have an undeniable charm.

The plan of the Borghese park has been the subject of much discussion. Falda's print shows only the

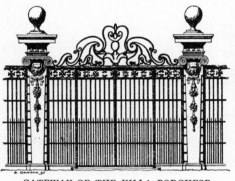

vicinity of the villa, and it has never been decided when the outlying grounds were laid out and how much they have been modified. At present the park, with its romantic groves of umbrella-pine, its ilex ave-

GATEWAY OF THE VILLA BORGHESE

nues, lake and amphitheatre, its sham ruins and little buildings scattered on irregular grassy knolls, has the appearance of a *jardin anglais* laid out at the end of the eighteenth century. Herr Tuckermann, persuaded that this park is the work of Giovanni Fontana, sees in him the originator of the "sentimental" English and German landscape-gardens, with their hermitages, mausoleums and temples of Friendship; but Percier and Fontaine, from whose plan of the park his inference is avowedly drawn, state that the grounds were much modified in 1789 by Jacob Moore, an English landscape-gardener, and by Pietro Camporesi of Rome. Herr Gurlitt, who seems to have overlooked this statement,

declares himself unable to pronounce on the date of this "creation already touched with the feeling of sentimen-, tality"; but Burckhardt, who is always accurate, says that the hippodrome and the temple of Æsculapius are of late date, and that the park was remodelled in the style of Poussin's landscapes in 1849.

About thirty years later than the Villa Borghese there arose its rival among the great Roman country-seats, the Villa Belrespiro or Pamphily, on the Janiculan. The Villa Pamphily, designed by Alessandro Algardi of Bologna, is probably the best known and most admired of Roman *maisons de plaisance*, and its incomparable ilex avenues and pine-woods, its rolling meadows and wide views over the Campagna, have enchanted many to whom its architectural beauties would not appeal.

The house, with its incrustations of antique bas-reliefs, cleverly adapted in the style of the Villa Medici, but with far greater richness and license of ornament, is a perfect example of the seventeenth-century villa, or rather casino; for it was really intended, not for a residence, but for a suburban lodge. It is flanked by lateral terraces, and the garden-front is a story lower than the other, so that the balcony of the first floor looks down on a great sunken garden, enclosed in the retaining-walls of the terraces, and richly adorned with statues in niches, fountains and *parterres de broderie*. Thence a double stairway descends to what was once the central portion of the gardens, a great amphitheatre bounded by ilex-

woods, with a *théâtre d'eaux* and stately flights of steps leading up to terraced ilex-groves; but all this lower garden was turned into an English park in the first half of the nineteenth century. One of the finest of Roman gardens fell a sacrifice to this senseless change; for in beauty of site, in grandeur of scale, and in the wealth of its Roman sculpture, the Villa Pamphily was unmatched. Even now it is full of interesting fragments; but the juxtaposition of an undulating lawn and dotty shrubberies to the stately garden-architecture about the villa has utterly destroyed the unity of the composition.

There is a legend to the effect that Le Nôtre laid out the park of the Villa Pamphily when he came to Rome in 1678; but Percier and Fontaine, who declare that there is nothing to corroborate the story, point out that the Villa Pamphily was begun over thirty years before Le Nôtre's visit. Absence of proof, however, means little to the average French author, eager to vindicate Le Nôtre's claim to being the father not only of French, but of Italian landscape-architecture; and M. Riat, in "L'Art des Jardins," repeats the legend of the Villa Pamphily, while Dussieux, in his "Artists Français à l'Etranger," anxious to heap further honours on his compatriot, actually ascribes to him the plan of the Villa Albani, which was laid out by Pietro Nolli nearly two hundred years after Le Nôtre's visit to Rome! Apparently the whole story of Le Nôtre's laying out of Italian gardens is based on the fact that he remodelled some

details of the Villa Ludovisi; but one need only compare the dates of his gardens with those of the principal Roman villas to see that he was the pupil and not the master of the great Italian garden-architects.

The last great country house built for a Roman cardinal is the villa outside the Porta Salaria which Carlo Marchionne built in 1746 for Cardinal Albani. In spite of its late date, the house still conforms to the type of Roman *villa suburbana* which originated with the Villa Medici; and it is interesting to observe that the Roman architects, having hit on so appropriate and original a style, did not fear to continue it in spite of the growing tendency toward a lifeless classicalism.

Cardinal Albani was a passionate collector of antique sculpture, and the villa, having been built to display his treasures, is appropriately planned with an open arcade between rusticated pilasters, which runs the whole length of the façade on the ground floor, and is continued by a long portico at each end. The grounds, laid out by Antonio Nolli, have been much extolled. Burckhardt sees in them traces of the reaction of French eighteenth-century gardening on the Italian school; but may it not rather be that, the Villa Albani being, by a rare exception, built on level ground, the site inevitably suggested a treatment similar to the French? It is hard to find anything specifically French, any motive which has not been seen again and again in Italy, in the plan of the Albani gardens; and their most charming feature, the

long ilex-walk connecting the villa with the *bosco*, exemplifies the Italian habit of providing shady access from the house to the wood. Dussieux, at any rate, paid Le Nôtre no compliment in attributing to him the plan of the Villa Albani; for the great French artist contrived to put more poetry into the flat horizons of Vaux and Versailles than Nolli has won from the famous view of the Campagna which is said to have governed the planning of the Villa Albani.

The grounds are laid out in formal quincunxes of clipped ilex, but before the house lies a vast sunken garden enclosed in terraces. The farther end of the garden is terminated by a semicircular portico called the *Caffè*, built later than the house, under the direction of Winckelmann; and in this structure, and in the architecture of the terraces, one sees the heavy touch of that neo-Grecianism which was to crush the life out of eighteenth-century art. The gardens of the Villa Albani seem to have been decorated by an archæologist rather than an artist. It is interesting to note that antique sculpture, when boldly combined with a living art, is one of the most valuable adjuncts of the Italian garden; whereas, set in an artificial evocation of its own past, it loses all its vitality and becomes as lifeless as its background.

One of the most charming of the smaller Roman villas lies outside the Porta Salaria, a mile or two beyond the Villa Albani. This is the country-seat of Prince Don

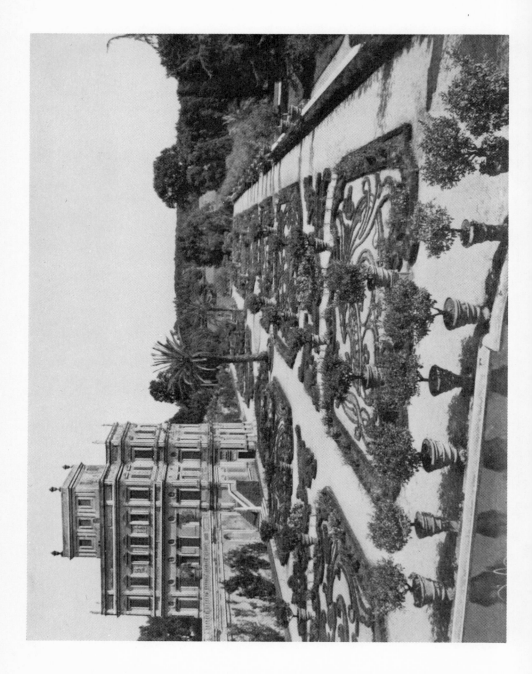

PARTERRES ON TERRACE, VILLA BELRESPIRO
(PAMPHILY-DORIA), ROME

Lodovico Chigi. In many respects it recalls the Sienese type of villa. At the entrance, the highroad is enlarged into a semicircle, backed by a wall with busts; and on the axis of the iron gates one sees first a court flanked by box-gardens, then an open archway running through the centre of the house, and beyond that, the vista of a long walk enclosed in high box-hedges and terminating in another semicircle with statues, backed by an ilex-planted mount. The plan has all the compactness and charm of the Tuscan and Umbrian villas. The level ground about the house is subdivided into eight square box-hedged gardens, four on a side, enclosing symmetrical box-bordered plots. Beyond these are two little groves with statues and benches. The ground falls away in farm-land below this level, leaving only the long central alley which appears to lead to other gardens, but which really ends in the afore-mentioned semicircle, behind which is a similar alley, running at right angles, and leading directly to the fields.

At the other end of Rome lies the only small Roman garden comparable in charm with Prince Chigi's. This is the Priorato, or Villa of the Knights of Malta, near Santa Sabina, on the Aventine. Piranesi, in 1765, remodelled and decorated the old chapel adjoining the house; and it is said that he also laid out the garden. If he did so, it shows how late the tradition of the Renaissance garden lingered in Italy; for there is no trace of romantic influences in the Priorato. The grounds

are small, for the house stands on a steep ledge over-
looking the Tiber, whence there is a glorious view of
St. Peter's and the Janiculan. The designer of the
garden evidently felt that it must be a mere setting to
this view ; and accordingly he laid out a straight walk,
walled with box and laurel and running from the gate
to the terrace above the river. The prospect framed in
this green tunnel is one of the sights of Rome ; and, by
a touch peculiarly Italian, the keyhole of the gate has
been so placed as to take it in. To the left of the
pleached walk lies a small flower-garden, planted with
square-cut box-trees, and enclosed in a high wall with
niches containing statues : a real " secret garden," full
of sunny cloistered stillness, in restful contrast to the
wide prospect below the terrace.

The grounds behind the Palazzo Colonna belong to
another type, and are an interesting example of the
treatment of a city garden, especially valuable now that
so many of the great gardens within the walls of Rome
have been destroyed.

The Colonna palace stands at the foot of the Quirinal
Hill, and the gardens are built on the steep slope behind
it, being entered by a stately gateway from the Via
Quirinale. On this upper level there is a charming
rectangular box-garden, with flower-plots about a central
basin. Thence one descends to two narrow terraces,
one beneath the other, planted with box and ilex, and
adorned with ancient marbles. Down the centre, start-

ing from the upper garden, there is an elaborate *château d'eau* of baroque design, with mossy urns and sea-gods, terminating in a basin fringed with ferns; and beneath this central composition the garden ends in a third wide terrace, planted with square-clipped ilexes, which look from above like a level floor of verdure. Graceful stone bridges connect this lowest terrace with the first-floor windows of the palace, which is divided from its garden by a narrow street; and the whole plan is an interesting example of the beauty and variety of effect which may be produced on a small steep piece of ground.

Of the other numerous gardens which once crowned the hills of Rome, but few fragments remain. The Villa Celimontana, or Mattei, on the Cælian, still exists, but its grounds have been so Anglicized that it is interesting chiefly from its site and from its associations with St. Philip Neri, whose seat beneath the giant ilexes is still preserved. The magnificent Villa Ludovisi has vanished, leaving only, amid a network of new streets, the Casino of the Aurora and a few beautiful fragments of architecture incorporated in the courtyard of the ugly Palazzo Margherita; and the equally famous Villa Negroni was swept away to make room for the Piazza delle Terme and the Grand Hotel. The Villa Sacchetti, on the slope of Monte Mario, is in ruins; in ruins the old hunting-lodge of Cecchignola, in the Campagna, on the way to the Divino Amore. These and many others are gone or going; but at every turn the watchful eye

still lights on some lingering fragment of old garden-art
—some pillared gateway or fluted *vasca* or broken
statue cowering in its niche—all testifying to what
Rome's crown of gardens must have been, and still full
of suggestion to the student of her past.

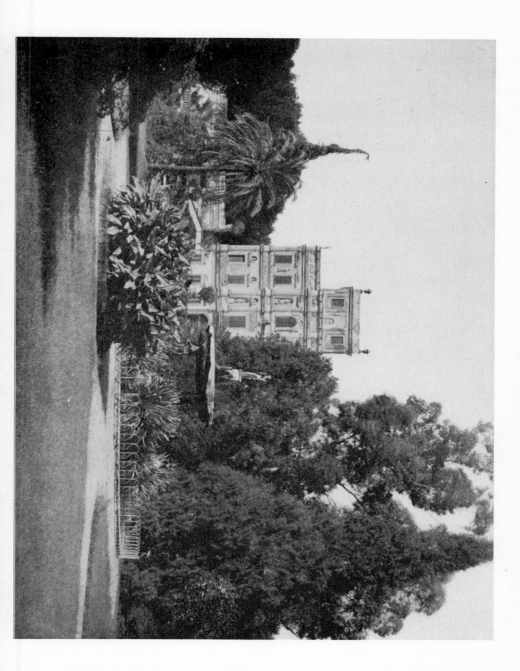

VIEW FROM LOWER GARDEN, VILLA BELRESPIRO
(PAMPHILY-DORIA), ROME

VILLAS NEAR ROME

IV

VILLAS NEAR ROME

I

CAPRAROLA AND LANTE

THE great cardinals did not all build their villas within sight of St. Peter's. One of them, Alexander Farnese, chose a site above the mountain village of Caprarola, which looks forth over the Etrurian plain strewn with its ancient cities — Nepi, Orte and Città Castellana — to Soracte, rising solitary in the middle distance, and the encircling line of snow-touched Apennines.

There is nothing in all Italy like Caprarola. Burckhardt calls it "perhaps the highest example of restrained majesty which secular architecture has achieved"; and Herr Gurlitt makes the interesting suggestion that Vignola, in building it, broke away from the traditional palace-architecture of Italy and sought his inspiration in France. "Caprarola," he says, "shows the northern castle in the most modern form it had then attained. . . .

We have to do here with one of the fortified residences rarely seen save in the north, but doubtless necessary in a neighbourhood exposed to the ever-increasing dangers of brigandage. Italy, indeed, built castles and fortified works, but the fortress-palace, equally adapted to peace and war, was almost unknown."

The numerous illustrated publications on Caprarola make it unnecessary to describe its complex architecture in detail. It is sufficient to say that its five bastions are surrounded by a deep moat, across which a light bridge at the back of the palace leads to the lower garden. To pass from the threatening façade to the wide-spread beauty of pleached walks, fountains and grottoes, brings vividly before one the curious contrasts of Italian country life in the transition period of the sixteenth century. Outside, one pictures the cardinal's soldiers and *bravi* lounging on the great platform above the village; while within, one has a vision of noble ladies and their cavaliers sitting under rose-arbours or strolling between espaliered lemon-trees, discussing a Greek manuscript or a Roman bronze, or listening to the last sonnet of the cardinal's court poet.

The lower garden of Caprarola is a mere wreck of overgrown box-parterres and crumbling wall and balustrade. Plaster statues in all stages of decay stand in the niches or cumber the paths; fruit-trees have been planted in the flower-beds, and the maidenhair withers in grottoes where the water no longer flows. The archi-

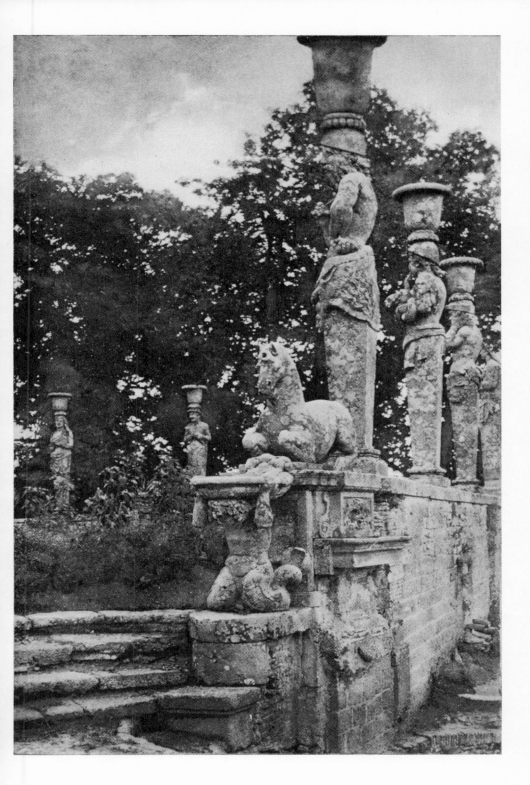

VILLA CAPRAROLA

tectural detail of the fountains and arches is sumptuous and beautiful, but the outline of the general plan is not easy to trace; and one must pass out of this enclosure and climb through hanging oak-woods to a higher level to gain an idea of what the gardens once were.

Beyond the woods a broad *tapis vert* leads to a level space with a circular fountain sunk in turf. Partly surrounding this is an architectural composition of rusticated arcades, between which a *château d'eau* descends the hillside from a grotto surmounted by two mighty river-gods, and forming the central motive of a majestic double stairway of rusticated stonework. This leads up to the highest terrace, which is crowned by Vignola's exquisite casino, surely the most beautiful garden-house in Italy. The motive of the arcades and stairway, though fine in itself, may be criticized as too massive and important to be in keeping with the delicate little building above; but once on the upper terrace, the lack of proportion is no longer seen and all the surroundings are harmonious. The composition is simple: around the casino, with its light arcades raised on a broad flight of steps, stretches a level box-garden with fountains, enclosed in a low wall surmounted by the famous Canephoræ seen in every picture of Caprarola—huge sylvan figures half emerging from their stone sheaths, some fierce or solemn, some full of rustic laughter. The audacity of placing that row of fantastic terminal divinities against reaches of illimitable air girdled in mountains

gives an indescribable touch of poetry to the upper garden of Caprarola. There is a quality of inevitableness about it—one feels of it, as of certain great verse, that it could not have been otherwise, that, in Vasari's happy phrase, it was *born, not built.*

Not more than twelve miles from Caprarola lies the other famous villa attributed to Vignola, and which one wishes he may indeed have built, if only to show how a great artist can vary his resources in adapting himself to a new theme. The Villa Lante, at Bagnaia, near Viterbo, appears to have been the work not of one cardinal, but of four. Raphael Riario, Cardinal Bishop of Viterbo, began it toward the end of the fifteenth century, and the work, carried on by his successors in the see, Cardinals Ridolfi and Gambara, was finally completed in 1588 by Cardinal Montalto, nephew of Sixtus V, who bought the estate from the bishops of Viterbo and bequeathed it to the Holy See. Percier and Fontaine believe that several architects collaborated in the work, but its unity of composition shows that the general scheme must have originated in one mind, and Herr Gurlitt thinks there is nothing to disprove that Vignola was its author.

Lante, like Caprarola, has been exhaustively sketched and photographed, but so perfect is it, so far does it surpass, in beauty, in preservation, and in the quality of garden-magic, all the other great pleasure-houses of Italy, that the student of garden-craft may always find

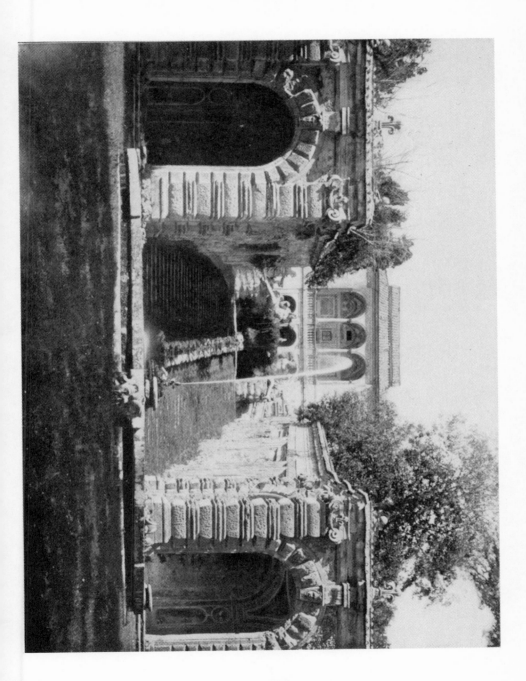

THE CASINO, VILLA FARNESE, CAPRAROLA

fresh inspiration in its study. If Caprarola is "a garden to look out from," Lante is one "to look into," not in the sense that it is enclosed, for its terraces command a wide horizon; but the pleasant landscape surrounding it is merely accessory to the gardens, a last touch of loveliness where all is lovely.

The designer of Lante understood this, and perceived that, the surroundings being unobtrusive, he might elaborate the foreground. The flower-garden occupies a level space in front of the twin pavilions; for instead of one villa there are two at Lante, absolutely identical, and connected by a *rampe douce* which ascends between them to an upper terrace. This peculiar arrangement is probably due to the fact that Cardinal Montalto, who built the second pavilion, found there was no other way of providing more house-room without disturbing the plan of the grounds. The design of the flower-garden is intricate and beautiful, and its box-bordered parterres surround one of the most famous and beautiful fountains in Italy. The abundance of water at Lante enabled the designer to produce a great variety of effects in what Germans call the "water-art," and nowhere was his invention happier than in planning this central fountain. It stands in a square tank or basin, surrounded by a balustrade, and crossed by four little bridges which lead to a circular balustraded walk, enclosing an inner basin from the centre of which rises the fountain. Bridges also cross from the circular walk to the platform on

which the fountain is built, so that one may stand under the arch of the water-jets, and look across the garden through a mist of spray.

Lante, doubly happy in its site, is as rich in shade as in water, and the second terrace, behind the pavilions, is planted with ancient plane-trees. Above this terrace rise three others, all wooded with plane and ilex, and down the centre, from the woods above, rushes the cascade which feeds the basin in the flower-garden. The terraces, with their balustrades and obelisks and double flights of steps, form a stately setting to this central *château d'eau*, through which the water gushes by mossy steps and channels to a splendid central composition of superimposed basins flanked by recumbent river-gods.

All the garden-architecture at Lante merits special study. The twin pavilions seem plain and insignificant after the brilliant elevations of the great Roman villas, but regarded as part of the garden-scheme, and not as dominating it, they fall into their proper place, and are seen to be good examples of the severe but pure style of the early cinque-cento. Specially interesting also is the treatment of the retaining-wall which faces the entrance to the grounds; and the great gates of the flower-gardens, and the fountains and garden-houses on the upper terraces, are all happy instances of Renaissance garden-art untouched by *barocchismo*.

At Lante, also, one sees one of the earliest examples

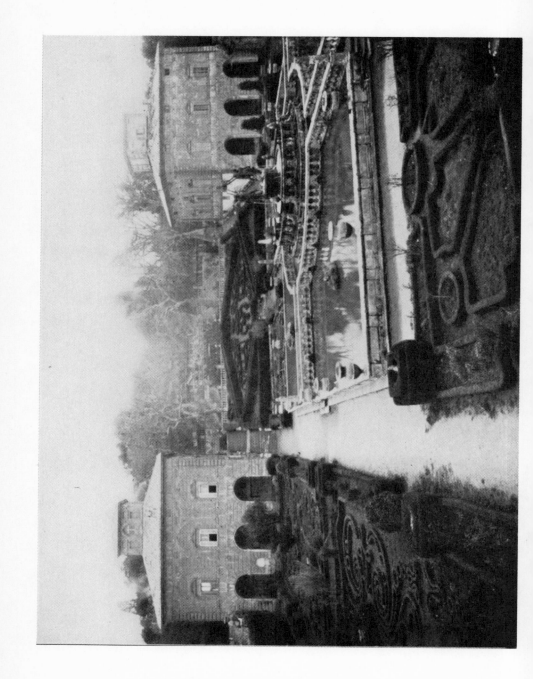

VILLA LANTE, BAGNAIA

of the inclusion of the woodland in the garden-scheme. All the sixteenth-century villas had small groves adjacent to the house, and the shade of the natural woodland was used, if possible, as a backing to the gardens; but at the Villa Lante it is boldly worked into the general scheme, the terraces and garden-architecture are skilfully blent with it, and its recesses are pierced by grass alleys leading to clearings where pools surrounded by stone seats slumber under the spreading branches.

The harmonizing of wood and garden is one of the characteristic features of the villas at Frascati; but as these are mostly later in date than the Lante grounds, priority of invention may be claimed for the designer of the latter. It was undoubtedly from the Italian park of the Renaissance that Le Nôtre learned the use of the woodland as an adjunct to the garden; but in France these parks had for the most part to be planted, whereas in Italy the garden-architect could use the natural woodland, which was usually hilly, and the effects thus produced were far more varied and interesting than those possible in the flat artificial parks of France.

II

VILLA D'ESTE

OF the three great villas built by cardinals beyond the immediate outskirts of Rome, the third and the most famous is the Villa d'Este at Tivoli.

Begun before 1540 by the Cardinal Bishop of Cordova, the villa became the property of Cardinal Ippolito d'Este, son of Alfonso I of Ferrara, who carried on its embellishment at the cost of over a million Roman scudi. Thence it passed successively to two other cardinals of the house of Este, who continued its adornment, and finally, in the seventeenth century, was inherited by the ducal house of Modena.

The villa, an unfinished barrack-like building, stands on a piazza at one end of the town of Tivoli, above gardens which descend the steep hillside to the gorge of the Anio. These gardens have excited so much admiration that little thought has been given to the house, though it is sufficiently interesting to merit attention. It is said to have been built by Pirro Ligorio, and surprising as it seems that this huge featureless pile should have been designed by the creator of the Casino del Papa, yet one observes that the rooms are decorated with the same fantastic pebble-work used in such profusion at the Villa Pia. In extenuation of the ugliness of the Villa d'Este it should, moreover, be remembered that its long façade is incomplete, save for the splendid central portico ; and also that, while the Villa Pia was intended as shelter for a summer afternoon, the great palace at Tivoli was planned to house a cardinal and his guests, including, it is said, "a suite of two hundred and fifty gentlemen of the noblest blood of Italy." When one pictures such a throng, with their

innumerable retainers, it is easy to understand why the Villa d'Este had to be expanded out of all likeness to an ordinary country house.

The plan is ingenious and interesting. From the village square only a high blank wall is visible. Through a door in this wall one passes into a frescoed corridor which leads to a court enclosed in an open arcade, with fountains in rusticated niches. From a corner of the court a fine intramural stairway descends to what is, on the garden side, the *piano nobile* of the villa. On this side, looking over the gardens, is a long enfilade of rooms, gaily frescoed by the Zuccheri and their school; and behind the rooms runs a vaulted corridor built against the side of the hill, and lighted by bull's-eyes in its roof. This corridor has lost its frescoes, but preserves a line of niches decorated in coloured pebbles and stucco-work, with gaily painted stucco caryatids supporting the arches; and as each niche contains a semicircular fountain, the whole length of the corridor must once have rippled with running water.

The central room opens on the great two-storied portico or loggia, whence one descends by an outer stairway to a terrace running the length of the building, and terminated at one end by an ornamental wall, at the other by an open loggia overlooking the Campagna. From this upper terrace, with its dense wall of box and laurel, one looks down on the towering cypresses and ilexes of the lower gardens. The grounds are not large,

but the impression produced is full of a tragic grandeur. The villa towers above so high and bare, the descent from terrace to terrace is so long and steep, there are such depths of mystery in the infinite green distances and in the cypress-shaded pools of the lower garden, that one has a sense of awe rather than of pleasure in descending from one level to another of darkly rustling green. But it is the omnipresent rush of water which gives the Este gardens their peculiar character. From the Anio, drawn up the hillside at incalculable cost and labour, a thousand rills gush downward, terrace by terrace, channelling the stone rails of the balusters, leaping from step to step, dripping into mossy conchs, flashing in spray from the horns of sea-gods and the jaws of mythical monsters, or forcing themselves in irrepressible overflow down the ivy-matted banks. The whole length of the second terrace is edged by a deep stone channel, into which the stream drips by countless outlets over a quivering fringe of maidenhair. Every side path or flight of steps is accompanied by its sparkling rill, every niche in the retaining-walls has its water-pouring nymph or gushing urn; the solemn depths of green reverberate with the tumult of innumerable streams. "The Anio," as Herr Tuckermann says, "throbs through the whole organism of the garden like its inmost vital principle."

The gardens of the Villa d'Este were probably begun by Pirro Ligorio, and, as Herr Gurlitt thinks, continued later by Giacomo della Porta. It will doubtless never

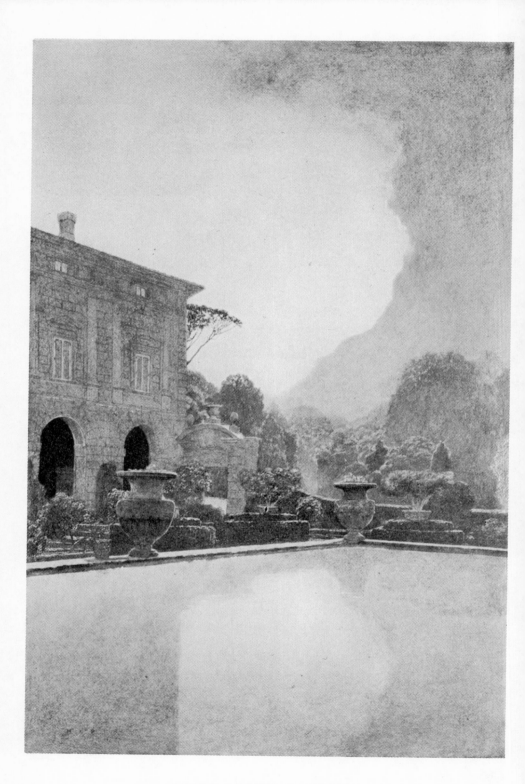

VILLA LANTE, BAGNAIA

be known how much Ligorio owed to the taste of Orazio Olivieri, the famous hydraulic engineer, who raised the Anio to the hilltop and organized its distribution through the grounds. But it is apparent that the whole composition was planned about the central fact of the rushing Anio : that the gardens were to be, as it were, an organ on which the water played. The result is extraordinarily romantic and beautiful, and the versatility with which the stream is used, the varying effects won from it, bear witness to the imaginative feeling of the designer.

When all has been said in praise of the poetry and charm of the Este gardens, it must be owned that from the architect's standpoint they are less satisfying than those of the other great cinque-cento villas. The plan is worthy of all praise, but the details are too complicated, and the ornament is either trivial or cumbrous. So inferior is the architecture to that of the Lante gardens and Caprarola that Burckhardt was probably right in attributing much of it to the seventeenth century. Here for the first time one feels the heavy touch of the baroque. The fantastic mosaic and stucco temple containing the water-organ above the great cascade, the arches of triumph, the celebrated "grotto of Arethusa," the often-sketched fountain on the second terrace, all seem pitiably tawdry when compared with the garden-architecture of Raphael or Vignola. Some of the details of the composition are absolutely puerile—such as the toy model of an ancient city, thought to be old Rome,

and perhaps suggested by the miniature " Valley of
Canopus " in the neighbouring Villa of Hadrian; and
there are endless complications of detail, where the
earlier masters would have felt the need of breadth and
simplicity. Above all, there is a want of harmony be-
tween the landscape and its treatment. The baroque
garden-architecture of Italy is not without charm, and
even a touch of the grotesque has its attraction in the
flat gardens of Lombardy or the sunny Euganeans;
but the cypress-groves of the Villa d'Este are too
solemn, and the Roman landscape is too august, to
suffer the nearness of the trivial.

III

FRASCATI

THE most famous group of villas in the Roman
country-side lies on the hill above Frascati. Here,
in the middle of the sixteenth century, Flaminio Pon-
zio built the palace of Mondragone for Cardinal
Scipione Borghese.[1] Aloft among hanging ilex-woods
rises the mighty pile on its projecting basement. This
fortress-like ground floor, with high-placed grated win-
dows, is common to all the earlier villas on the brig-
and-haunted slopes of Frascati. An avenue of ancient
ilexes (now cruelly cut down) leads up through the park
to the villa, which is preceded by a great walled

[1] The villa was begun by Martino Lunghi the Elder, in 1567, for the Cardinal
Marco d' Altemps, enlarged by Pope Gregory VII, and completed by Paul V and
his nephew, Cardinal Scipione Borghese. See Gustav Ebe, " Die Spätrenaissance."

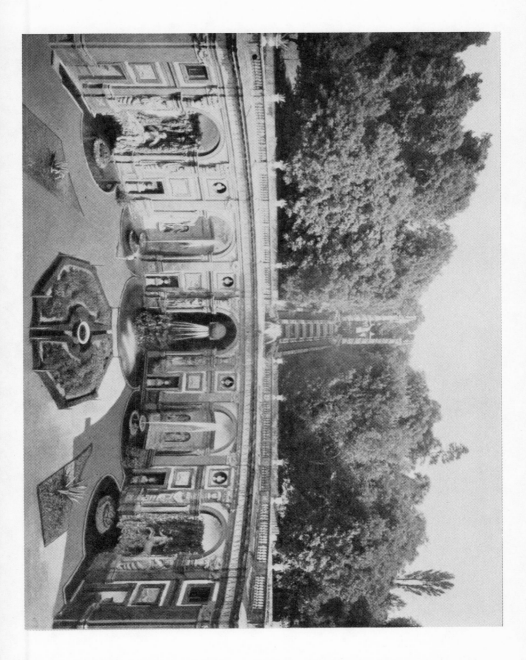

CASCADE AND ROTUNDA, VILLA ALDOBRANDINI, FRASCATI

courtyard, with fountains in the usual rusticated niches. To the right of this court is another, flanked by the splendid loggia of Vignola, with the Borghese eagles and dragons alternating in its sculptured spandrels, and a vaulted ceiling adorned with *stucchi*—one of the most splendid pieces of garden-architecture in Italy.

At the other end of this inner court, which was formerly a flower-garden, Giovanni Fontana, whose name is identified with the fountains of Frascati, constructed a *théâtre d'eau*, raised above the court, and approached by a double ramp elaborately inlaid in mosaic. This ornate composition, with a series of mosaic niches simulating arcaded galleries in perspective, is now in ruins, and the most impressive thing about Mondragone is the naked majesty of its great terrace, unadorned save by a central fountain and two tall twisted columns, and looking out over the wooded slopes of the park to Frascati, the Campagna, and the sea.

On a neighbouring height lies the more famous Villa Aldobrandini, built for the cardinal of that name by Giacomo della Porta in 1598, and said by Evelyn, who saw it fifty years later, "to surpass the most delicious places . . . for its situation, elegance, plentiful water, groves, ascents and prospects."

The house itself does not bear comparison with such buildings as the Villa Medici or the Villa Pamphily. In style it shows the first stage of the baroque, before that school had found its formula. Like all the hill-built villas of Frascati, it is a story lower at the back than in

front; and the roof of this lower story forms at each end a terrace level with the first-floor windows. These terraces are adorned with two curious turrets, resting on baroque basements and crowned by swallow-tailed crenellations—a fantastic reversion to mediævalism, more suggestive of " Strawberry Hill Gothic " than of the Italian seventeenth century.

Orazio Olivieri and Giovanni Fontana are said to have collaborated with Giacomo della Porta in designing the princely gardens of the villa. Below the house a series of splendid stone terraces lead to a long *tapis vert*, with an ilex avenue down its centre, which descends to the much-admired grille of stone and wrought-iron enclosing the grounds at the foot of the hill. Behind the villa, in a semicircle cut out of the hillside, is Fontana's famous water-theatre, of which Evelyn gives a picturesque description: " Just behind the Palace . . . rises a high hill or mountain all overclad with tall wood, and so formed by nature as if it had been cut out by art, from the summit of which falls a cascade . . . precipitating into a large theatre of water. Under this is an artificial grot wherein are curious rocks, hydraulic organs, and all sorts of singing birds, moving and chirping by force of the water, with several other pageants and surprising inventions. In the centre of one of these rooms rises a copper ball that continually dances about three feet above the pavement, by virtue of a wind conveyed secretly to a hole beneath it; with

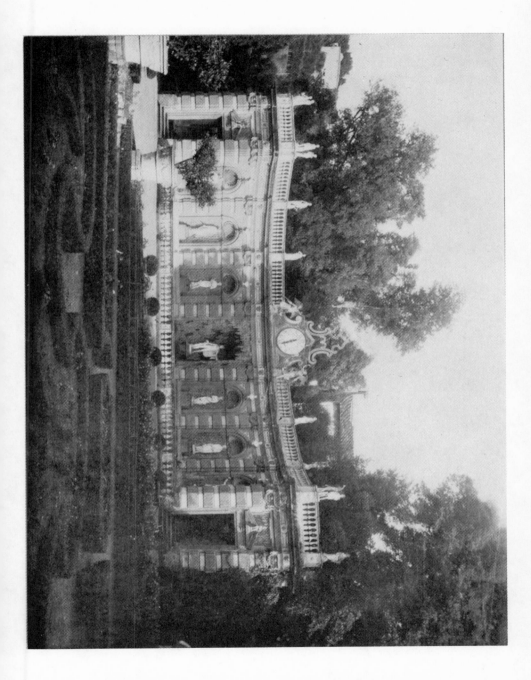

GARDEN OF VILLA LANCELLOTTI, FRASCATI

many other devices for wetting the unwary spectators.
. . . In one of these theatres of water is an Atlas
spouting, . . . and another monster makes a terrible
roaring with a horn; but, above all, the representation
of a storm is most natural, with such fury of rain, wind
and thunder as one would imagine oneself in some
extreme tempest."

Atlas and the monster are silent, and the tempest has
ceased to roar; but the architecture of the great water-
theatre remains intact. It has been much extolled by so
good a critic as Herr Gurlitt, yet compared with Vi-
gnola's loggia at Mondragone or the terrace of the Orti
Farnesiani, it is a heavy and uninspired production. It
suffers also from too great proximity to the villa, and
from being out of scale with the latter's modest eleva-
tion: there is a distinct lack of harmony between the
two façades. But even Evelyn could not say too much
in praise of the glorious descent of the cascade from the
hilltop. It was in the guidance of rushing water that
the Roman garden-architects of the seventeenth century
showed their poetic feeling and endless versatility; and
the architecture of the upper garden at the Aldobrandini
merits all the admiration which has been wasted on its
pompous theatre.

Another example of a *théâtre d'eau*, less showy but
far more beautiful, is to be seen at the neighbouring Villa
Conti (now Torlonia). Of the formal gardens of this
villa there remain only the vast terraced stairways which

now lead to an ilex-grove level with the first story of the villa. This grove is intersected by mossy alleys, leading to circular clearings where fountains overflow their wide stone basins, and benches are ranged about in the deep shade. The central alley, on the axis of the villa, leads through the wood to a great grassy semi-circle at the foot of an ilex-clad hill. The base of the hillside is faced with a long arcade of twenty niches, divided by pilasters, and each containing a fountain. In the centre is a great baroque pile of rock-work, from which the spray tosses into a semicircular basin, which also receives the cascade descending from the hilltop. This cascade is the most beautiful example of fountain-architecture in Frascati. It falls by a series of inclined stone ledges into four oval basins, each a little wider than the one above it. On each side, stone steps which follow the curves of the basins lead to a grassy plateau above, with a balustraded terrace overhanging the rush of the cascade. The upper plateau is enclosed in ilexes, and in its centre is one of the most beautiful fountains in Italy — a large basin surrounded by a richly sculptured balustrade. The plan of this fountain is an interesting example of the variety which the Italian garden-architects gave to the outline of their basins. Even in the smaller gardens the plan of these basins is varied with taste and originality; and the small wall-fountains are also worthy of careful study.

Among the villas of Frascati there are two, less

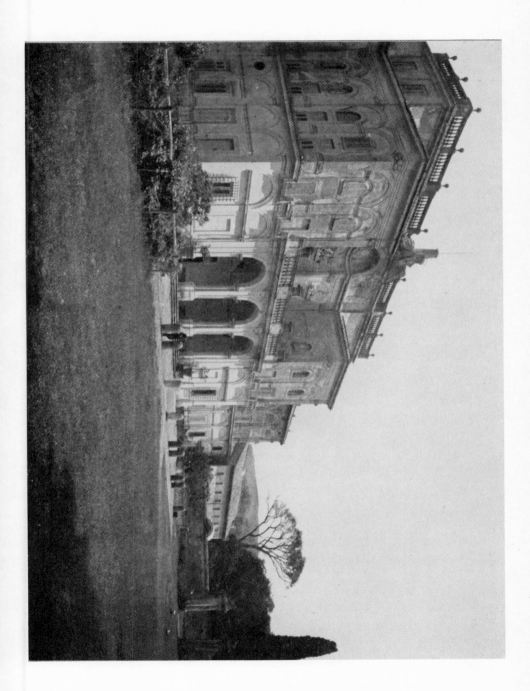

CASINO, VILLA FALCONIERI, FRASCATI

famous than the foregoing, but even more full of a romantic charm. One is the Villa Muti, a mile or two beyond the town, on the way to Grotta Ferrata. From the gate three ancient ilex avenues lead to the villa, the central one being on the axis of the lowest garden. The ground rises gradually toward the house, and the space between the ilex avenues was probably once planted in formal *boschi*, as fragments of statuary are still seen among the trees. The house, set against the hillside, with the usual fortress-like basement, is two stories lower toward the *basse-cour* than toward the gardens. The avenue to the left of the entrance leads to a small garden, probably once a court, in front of the villa, whence one looks down over a mighty retaining-wall at the *basse-cour* on the left. On the right, divided from the court by a low wall surmounted by vases, lies the most beautiful box-garden in Italy, laid out in an elaborate geometrical design, and enclosed on three sides by high clipped walls of box and laurel, and on the fourth by a retaining-wall which sustains an upper garden. Nothing can surpass the hushed and tranquil beauty of the scene. There are no flowers or bright colours — only the contrasted tints of box and ilex and laurel, and the vivid green of the moss spreading over damp paths and ancient stonework.

In the upper garden, which is of the same length but narrower, the box-parterres are repeated. This garden, at the end nearest the villa, has a narrow raised terrace,

with an elaborate architectural retaining-wall, containing a central fountain in stucco-work. Steps flanked by statues lead up to this fountain, and thence one passes by another flight of steps to the third, or upper, garden, which is level with the back of the villa. This third garden, the largest of the three, was once also laid out in formal parterres and *bosquets* set with statues, and though it has now been remodelled in the landscape style, its old plan may still be traced. Before it was destroyed the three terraces of the Villa Muti must have formed the most enchanting garden in Frascati, and their plan and architectural details are worthy of careful study, for they belong to the rare class of small Italian gardens where grandeur was less sought for than charm and sylvan seclusion, and where the Latin passion for the monumental was subordinated to a desire for moderation and simplicity.

The Villa Falconieri, on the hillside below Mondragone, is remarkable for the wealth of its garden-architecture. The grounds are entered by two splendid stone gateways, the upper one being on an axis with the villa. A grass avenue leads from this gate to an arch of triumph, a rusticated elevation with niches and statues, surmounted by the inscription " Horatius Falconieris," and giving access to the inner grounds. Hence a straight avenue runs between formal ilex-groves to the court before the house. On the right, above the *bosco*, is a lofty wall of rock, picturesquely

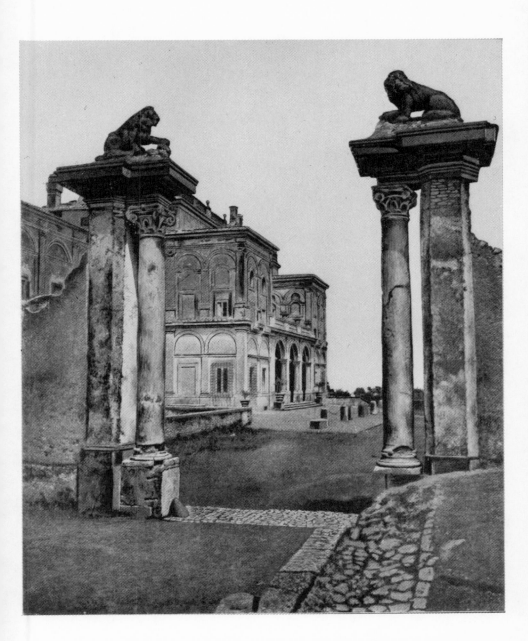

THE ENTRANCE, VILLA FALCONIERI, FRASCATI

overgrown by shrubs and creepers, with busts and other fragments of antique sculpture set here and there on its projecting ledges. This natural cliff sustains an upper plateau, where there is an oblong artificial water (called " the lake ") enclosed in rock-work and surrounded by a grove of mighty cypresses. From this shady solitude the wooded slopes of the lower park are reached by a double staircase so simple and majestic in design that it harmonizes perfectly with the sylvan wildness which characterizes the landscape. This staircase should be studied as an example of the way in which the Italian garden-architects could lay aside exuberance and whimsicality when their work was intended to blend with some broad or solemn effect of nature.

The grounds of the Villa Falconieri were laid out by Cardinal Ruffini in the first half of the sixteenth century, but the villa was not built till 1648. It is one of the most charming creations of Borromini, that brilliant artist in whom baroque architecture found its happiest expression; and the Villa Falconieri makes one regret that he did not oftener exercise his fancy in the construction of such pleasure-houses. The elevation follows the tradition of the Roman *villa suburbana*. The centre of the ground floor is an arcaded loggia, the roof of which forms a terrace to the recessed story above; while the central motive of this first story is another semicircular recess, adorned with stucco ornament and surmounted by a broken pediment. The

attic story is set still farther back, so that its balustraded roof-line forms a background for the richly decorated façade, and the building, though large, thus preserves the airy look and lightness of proportion which had come to be regarded as suited to the suburban pleasure-house.

To the right of the villa, the composition is prolonged by a gateway with coupled columns surmounted by stone dogs, and leading from the forecourt to the adjoining *basse-cour*. About the latter are grouped a number of low farm-buildings, to which a touch of the baroque gives picturesqueness. In the charm of its elevation, and in the happy juxtaposition of garden-walls and outbuildings, the Villa Falconieri forms the most harmonious and successful example of garden-architecture in Frascati.

The elevation which most resembles it is that of the Villa Lancellotti. Here the house, which is probably nearly a century earlier, shows the same happy use of the open loggia, which in this case forms the central feature of the first story, above a stately pedimented doorway. The loggia is surmounted by a kind of square-headed gable crowned by a balustrade with statues, and the façade on each side of this central composition is almost Tuscan in its severity. Before the house lies a beautiful box-garden of intricate design, enclosed in high walls of ilex, with the inevitable *théâtre d'eau* at its farther end. This is a semicircular compo-

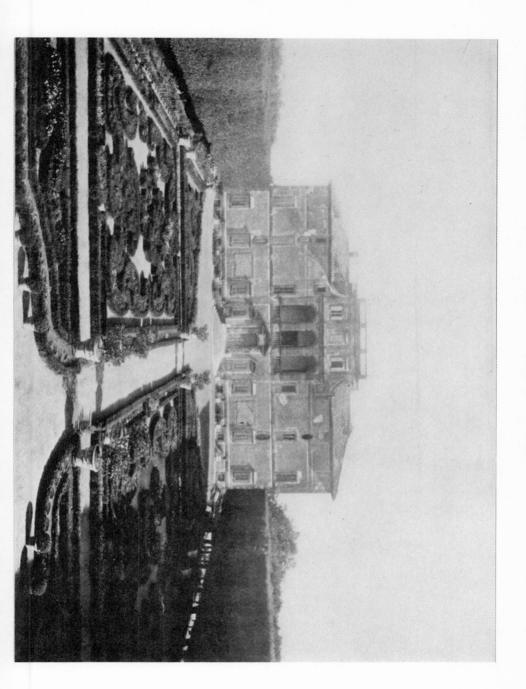

VILLA LANCELLOTTI, FRASCATI

sition, with statues in niches between rusticated pilasters, and a central grotto whence a fountain pours into a wide balustraded basin; the whole being surmounted by another balustrade, with a statue set on each pier. It is harmonious and dignified in design, but unfortunately a fresh coating of brown and yellow paint has destroyed that exquisite *patina* by means of which the climate of Italy effects the gradual blending of nature and architecture.

GENOESE VILLAS

V

GENOESE VILLAS

GENOA, one of the most splendour-loving cities in Italy, had almost always to import her splendour. In reading Soprani's " Lives of the Genoese Painters, Sculptors and Architects," one is struck by the fact that, with few exceptions, these worthies were Genoese only in the sense of having placed their talents at the service of the merchant princes who reared the marble city above its glorious harbour.

The strength of the race lay in other directions; but, as is often the case with what may be called people of secondary artistic instincts, the Genoese pined for the beauty they could not create, and in the sixteenth century they called artists from all parts of Italy to embody their conceptions of magnificence. Two of the most famous of these, Fra Montorsoli and Pierin del Vaga, came from Florence, Galeazzo Alessi from Perugia, Giovanni Battista Castello from Bergamo; and it is to the genius of these four men, sculptor, painter, architect, and *stuccatore* (and each more or less versed in the crafts of the others), that Genoa owes the greater part of her magnificence.

Fra Giovanni Angelo Montorsoli, the Florentine, must here be named first, since his chief work, the Palazzo Andrea Doria, built in 1529, is the earliest of the great Genoese villas. It is also the most familiar to modern travelers, for the other beautiful country houses which formerly crowned the heights above Genoa, from Pegli to Nervi, have now been buried in the growth of manufacturing suburbs, so that only the diligent seeker after villa-architecture will be likely to come upon their ruined gardens and peeling stucco façades among the factory chimneys of Sampierdarena or the squalid tenements of San Fruttuoso.

The great Andrea Doria, "Admiral of the Navies of the Pope, the Emperor, the King of France and the Republic of Genoa," in 1521 bought the villas Lomellini and Giustiniani, on the western shore of the port of Genoa, and throwing the two estates together, created a villa wherein "to enjoy in peace the fruits of an honoured life"—so runs the inscription on the outer wall of the house.

Fra Montorsoli was first and foremost a sculptor, a pupil of Michelangelo's, a plastic artist to whom architecture was probably of secondary interest. Partly perhaps for this reason, and also because the Villa Doria was in great measure designed to show the frescoes of Pierin del Vaga, there is little elaboration in its treatment. Yet the continuous open loggia on the ground floor, and the projecting side colonnades enclosing the

upper garden, give an airy elegance to the water-front, and make it, in combination with its mural paintings and stucco-ornamentation, and the sculpture of the gardens, one of the most villa-like of Italian villas. The gardens themselves descend in terraces to the shore, and contain several imposing marble fountains, among them one with a statue of Neptune, executed in 1600 by the Carloni, and supposed to be a portrait of the great Admiral.

The house stands against a steep terraced hillside, formerly a part of the grounds, but now unfortunately divided from them by the railway cutting. A wide *tapis vert* still ascends the hill to a colossal Jupiter (under which the Admiral's favourite dog is said to be buried); and when the villa is seen from the harbour one understands how necessary this stately terraced background was to the setting of the low-lying building. Beautiful indeed must have been the surroundings of the villa when Evelyn visited it in 1644, and described the marble terraces above the sea, the aviary "wherein grew trees of more than two feet in diameter, besides cypress, myrtles, lentiscuses and other rare shrubs," and "the other two gardens full of orange-trees, citrons and pomegranates, fountains, grots and statues." All but the statues have now disappeared, yet much of the old garden-magic lingers in the narrow strip between house and sea. It is the glory of the Italian garden-architects that neglect and disintegration cannot wholly mar the

effects they were skilled in creating: effects due to such a fine sense of proportion, to so exquisite a perception of the relation between architecture and landscape, between verdure and marble, that while a trace of their plan remains one feels the spell of the whole.

When Rubens came to Genoa in 1607 he was so impressed by the magnificence of its great street of palaces — the lately built Strada Nuova — that he recorded his admiration in a series of etchings, published in Antwerp in 1622 under the title " Palazzi di Genova," a priceless document for the student of Renaissance architecture in Italy, since the Flemish master did not content himself with mere impressionist sketches, like Canaletto's fanciful Venetian etchings, but made careful architectural drawings and bird's-eye views of all the principal Genoese palaces. As many of these buildings have since been altered, Rubens's volume has the additional value of preserving a number of interesting details which might never have been recovered by subsequent study.

The Strada Nuova of Genoa, planned by Galeazzo Alessi between 1550 and 1560, is the earliest example in Europe of a street laid out by an architect with deliberate artistic intent, and designed to display the palaces with which he subsequently lined it. Hitherto, streets had formed themselves on the natural lines of traffic, and individual houses had sprung up along them without much regard to the site or style of their nearest neighbors. The Strada Nuova, on the contrary, was planned

and carried out homogeneously, and was thus the progenitor of all the great street plans of modern Europe—of the Place Royale and the Place Vendôme in Paris, the great Place at Nancy, the grouping of Palladian palaces about the Basilica of Vicenza, and all subsequent attempts to create an organic whole out of a number of adjacent buildings. Even Lenfant's plan of Washington may be said to owe its first impulse to the Perugian architect's conception of a street of palaces.

When Alessi projected this great work he had open ground to build on, though, as Evelyn remarked, the rich Genoese merchants had, like the Hollanders, " little or no extent of ground to employ their estates in." Still, there was space enough to permit of spreading porticoes and forecourts, and to one of the houses in the Strada Nuova Alessi gave the ample development and airy proportions of a true *villa suburbana*. This is the Palazzo Parodi, which, like the vanished Sauli palace, shows, instead of the block plan of the city dwelling, a central *corps de bâtiment* with pavilions crowned by open loggias, and a rusticated screen dividing the court from the street. It is curious that, save in the case of the beautiful Villa Sauli (now completely rebuilt), Alessi did not repeat this appropriate design in the country houses with which he adorned the suburbs of Genoa—those " ravishing retirements of the Genoese nobility " which prolonged the splendour of the city for miles along the coast. Of his remaining villas, all are built on the

block plan, or with but slight projections, and rich though they are in detail, and stately in general composition, they lack that touch of fantasy which the Roman villa-architects knew how to impart.

Before pronouncing this a defect, however, one must consider the different conditions under which Alessi and his fellow-architects in Genoa had to work. Annibale Lippi, Pirro Ligorio, Giacomo della Porta and Carlo Borromini reared their graceful loggias and stretched their airy colonnades against masses of luxuriant foliage and above a far-spreading landscape,

> wonderful
> To the sea's edge for gloss and gloom,

while Alessi and Montorsoli had to place their country houses on narrow ledges of waterless rock, with a thin coating of soil parched by the wind, and an outlook over the serried roofs and crowded shipping of a commercial city. The Genoese gardens are mere pockets of earth in coigns of masonry, where a few olives and bay-trees fight the sun-glare and sea-wind of a harsh winter and a burning summer. The beauty of the prospect consists in the noble outline of the harbour, enclosed in exquisitely modelled but leafless hills, and in the great blue stretch of sea on which, now and then, the mountains of Corsica float for a moment. It will be seen that, amid such surroundings, the architectural quality must predominate over the picturesque or natu-

ralistic. Not only the natural restrictions of site and soil, but the severity of the landscape and the nearness of a great city, made it necessary that the Genoese villa-architects should produce their principal effects by means of masonry and sculpture, rather than of water and verdure. The somewhat heavy silhouette of the Genoese country houses is thus perhaps partly explained; for where the garden had to be a stone monument, it would have been illogical to make the house less massive.

The most famous of Alessi's villas lies in the once fashionable suburb of Sampierdarena, to the west of Genoa. Here, along the shore, were clustered the most beautiful pleasure-houses of the merchant princes. The greater number have now been turned into tenements for factory-workers, or into actual factories, while the beautiful gardens descending to the sea have been cut in half by the railway and planted with cabbages and mulberries. Amid this labyrinth of grimy walls, crumbling loggias and waste ground heaped with melancholy refuse, it is not easy to find one's way to the Villa Imperiali (now Scassi), the masterpiece of Alessi, which stands as a solitary witness to the former "ravishments" of Sampierdarena. By a happy chance this villa has become the property of the municipality, which has turned the house into a girls' school, while the grounds are used as a public garden; and so well have house and grounds been preserved that the student of architecture may here obtain a good idea of the magnificence

with which the Genoese nobles surrounded even their few weeks of *villeggiatura*. To match such magnificence, one must look to one of the great villas of the Roman cardinals; and, with the exception of the Villa Doria Pamphily (which is smaller) and of the Villa Albani, it would be difficult to cite an elevation where palatial size is combined with such lavish richness of ornament.

Alessi was once thought to have studied in Rome under Michelangelo; but Herr Gurlitt shows that the latter was absent from Rome from 1516 to 1535—that is, precisely during what must have been the formative period of Alessi's talent. The Perugian architect certainly shows little trace of Michelangelesque influences, but seems to derive rather from the school of his own great contemporary, Palladio.

The Villa Scassi, with its Tuscan order below and fluted Corinthian pilasters above, its richly carved frieze and cornice, and its beautiful roof-balustrade, is perhaps more familiar to students than any other example of Genoese suburban architecture. Almost alone among Genoese villas, it stands at the foot of a hill, with gardens rising behind it instead of descending below it to the sea. Herr Gurlitt thinks these grounds are among the earliest in Italy in which the narrow mediæval *hortus inclusus* was blent with the wider lines of the landscape; indeed, he makes the somewhat surprising statement that " all the later garden-craft has its source in Alessi, who,

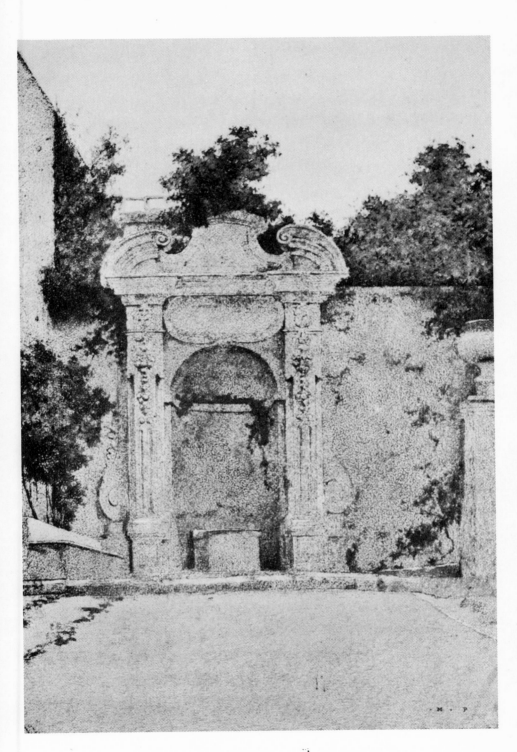

A GARDEN-NICHE, VILLA SCASSI, GENOA

in the Scassi gardens, has shown to the full his characteristic gift for preserving unity of conception in multiplicity of form."

There could be no better definition of the garden-science of the Italian Renaissance; and if, as it seems probable, the Scassi gardens are earlier in date than the Boboli and the Orti Farnesiani, they certainly fill an important place in the evolution of the pleasure-ground; but the Vatican gardens, if they were really designed by Antonio da Sangallo, must still be regarded as the source from which the later school of landscape-architects drew their first inspiration. It was certainly here, and in the unfinished gardens of the Villa Madama, that the earliest attempts were made to bring the untamed forms of nature into relation with the disciplined lines of architecture.

Herr Gurlitt is, however, quite right in calling attention to the remarkable manner in which the architectural lines of the Scassi gardens have been adapted to their site, and also to the skill with which Alessi contrived the successive transition from the formal surroundings of the house to the sylvan freedom of the wooded hilltop beneath which it lies.

A broad terrace, gently sloping with the natural grade of the land, leads up to a long level walk beneath the high retaining-wall which sustains the second terrace. In the centre of this retaining-wall is a beautifully designed triple niche, divided by Atlantides supporting a

delicately carved entablature, while a double flight of steps encloses this central composition. Niches with statues and marble seats also adorn the lateral walls of the gardens, and on the upper terrace is a long tank or canal, flanked by clipped shrubs and statues. Thence an inclined path leads to a rusticated temple with *colonnes torses*, and statues in niches above fluted basins into which water once flowed; and beyond this there is a winding ascent to the grove which crowns the hill. All the architectural details of the garden are remarkable for a classical purity and refinement, except the rusticated temple, of which the fantastic columns are carved to resemble tree-trunks. This may be of later date; but if contemporary, its baroque style was probably intended to mark the transition from the formality of the lower gardens to the rustic character of the naturalistic landscape above — to form, in fact, a gate from the garden to the park.

The end of the sixteenth century saw this gradual recognition of nature, and adoption of her forms, in the architecture and sculpture of the Italian pleasure-house, and more especially in those outlying constructions which connected the formal and the sylvan portions of the grounds. "In mid-Renaissance garden-architecture," as Herr Tuckermann puts it, " the relation between art and landscape is reversed. Previously the garden had had to adapt itself to architecture; now architectural forms are forced into a resemblance with nature."

Bernini was the great exponent of this new impulse, though it may be traced back as far as Michelangelo. It was Bernini who first expressed in his fountains the tremulous motion and shifting curves of water, and who put into his garden-sculpture that rustle of *plein air* which the modern painter seeks to express in his landscapes. To trace the gradual development of this *rapprochement* to nature at a period so highly artificial would be beyond the scope of these articles; but in judging the baroque garden architecture and sculpture of the late Renaissance, it should be remembered that they are not the expression of a wilful eccentricity, but an attempted link between the highly conventionalized forms of urban art and that life of the fields and woods which was beginning to charm the imagination of poets and painters.

On the height above the Acqua Sola gardens, on the eastern side of Genoa, lies Alessi's other great country house, the Villa Pallavicini alle Peschiere—not to be confounded with the ridiculous Villa Pallavicini at Pegli, a brummagem creation of the early nineteenth century, to which the guide-books still send throngs of unsuspecting tourists, who come back imagining that this tawdry jumble of weeping willows and Chinese pagodas, mock Gothic ruins and exotic vegetation, represents the typical "Italian garden," of which so much is said and so little really known.

The Villa Pallavicini alle Peschiere (a drawing of

185

which may be seen in Rubens's collection) is in site and design a typical Genoese suburban house of the sixteenth century. The lower story has a series of arched windows between Ionic pilasters; above are square-headed windows with upper lights, divided by fluted Corinthian pilasters and surmounted by a beautiful cornice and a roof-balustrade of unusual design, in which groups of balusters alternate with oblong panels of richly carved openwork. The very slightly projecting wings have, on both stories, arched recesses in which heroic statues are painted in *grisaille*.

The narrow ledge of ground on which the villa is built permits only of a broad terrace in front of the house, with a central basin surmounted by a beautiful winged figure and enclosed in stone-edged flower-beds. Stately flights of steps lead down to a lower terrace, of which the mighty retaining-wall is faced by a Doric portico, with a recessed loggia behind it. From this level other flights of steps, flanked by great balustraded walls nearly a hundred feet high, descend to a third terrace, narrower than the others, whence one looks down into lower-lying gardens, wedged into every projecting shelf of ground between palace roofs and towering slopes of masonry; while directly beneath this crowded foreground sparkles the blue expanse of the Mediterranean.

On a higher ledge, above the Villa Pallavicini, lies the Villa Durazzo-Grapollo, perhaps also a work of Alessi's. Here the unusual extent of ground about the house has

permitted an interesting development of landscape-archi-
tecture. A fine pedimented gateway with rusticated piers
gives admission to a straight avenue of plane-trees lead-
ing up to the house, which is a dignified building with
two stories, a *mezzanin* and an attic. The windows on
the ground floor are square-headed, with oblong sunk
panels above; while on the first floor there is a slightly
baroque movement about the architraves, and every other
window is surmounted by a curious shell-shaped pedi-
ment. On the garden side a beautiful marble balcony
forms the central motive of the *piano nobile*, and the
roof is enclosed in a balustrade with alternate solid
panels and groups of balusters. The plan is oblong,
with slightly projecting wings, adorned on both stories
with coupled pilasters, which on the lower floor are rus-
ticated and above are fluted Corinthian, painted on the
stucco surface of the house. This painting of archi-
tectural ornament is very characteristic of Genoese
architecture, and was done with such skill that, at a
little distance, it is often impossible to distinguish a
projecting architectural member from its frescoed coun-
terfeit.

In front of the villa is a long narrow formal garden,
supported on three sides by a lofty retaining-wall. Down
the middle of this garden, on an axis with the central
doorway of the façade, runs a canal terminated by
reclining figures of river-gods and marble dolphins
spouting water. An ilex-walk flanks it on each side,

and at the farther end a balustrade encloses this upper garden, and two flights of steps, with the usual central niche, lead to the next level. Here there is a much greater extent of ground, and the old formal lines have been broken up into the winding paths and shrubberies of a *jardin anglais*. Even here, however, traces of the original plan may be discovered, and statues and fountains are scattered with charming effect among the irregular plantations, while paths between clipped walls of green lead to beautiful distant views of the sea and mountains. Specially interesting is the treatment of the lateral retaining-walls of the upper garden. In these immense ramparts of masonry have been cut tunnels decorated with shellwork and stucco ornament, which lead up by a succession of wide steps to the ground on a level with the house. One of these tunnels contains a series of pools of water, which finally pour into a stream winding through a romantic *boschetto* on a lower level. Here, as at the Villa Scassi, all the garden-architecture is pure and dignified in style, and there is great beauty in the broad and simple treatment of the upper terrace, with its canal and ilex-walks.

From the terraces of the Villa Durazzo one looks forth over the hillside of San Francesco d'Albaro, the suburb which balances Sampierdarena on the east. Happily this charming district is still a fashionable villeggiatura, and the houses which Alessi built on its slopes stand above an almost unaltered landscape of

garden and vineyard. A fine road crosses the Bisagno and leads up between high walls and beautiful hanging gardens, passing at every turn some charming villa-façade in its setting of cypresses and camellias. Among these, one should not overlook the exquisite little Para-disino, a pale-green toy villa with Ionic pilasters and classic pediment, perched above a high terrace on the left of the ascent.

Just above stands the Paradiso (or Villa Cambiaso), another masterpiece of Alessi's,[1] to which it is almost impossible to obtain admission. Unfortunately, the house stands far back from the road, above intervening terraces and groves, and one can obtain only an imperfect glimpse of its beautiful façade, which is as ornate and imposing as that of the Villa Scassi, and of garden-walks lined with clipped hedges and statues.

At Alessi's other Villa Cambiaso, higher up the hill of San Francesco d'Albaro, a more hospitable welcome awaits the sight-seer. Here admission is easily obtained, and it is possible to study and photograph at leisure. This villa is remarkable for the beauty of the central loggia on the ground floor of the façade: a grand Doric arcade, leading into a two-storied atrium designed in the severest classical spirit. So suggestive is this of the great loggia of the Villa Bombicci, near Florence, that one understands why Alessi was called the

[1] In his " Baukunst der Renaissance in Italien " (Part II, Vol. V) Dr. Josef Durm, without citing his authority, says that the Villa Paradiso was built in 1600 by Andrea Ceresola, called Vanove.

189

pupil of Michelangelo. At the back of the house there is (as at the Villa Bombicci) a fine upper loggia, and the wide spacing of the windows on the ground floor, and the massiveness and simplicity of all the architectural details, inevitably recall the Tuscan style. Little is left of the old gardens save a *tapis vert* flanked by clipped hedges, which descends to an iron grille on a lower road; but the broad grassy space about the house has a boundary-wall with a continuous marble bench, like that at the Villa Pia in the Vatican gardens.

In the valley between San Francesco d'Albaro and the Bisagno lies the dismal suburb of San Fruttuoso. Here one must seek, through a waste of dusty streets lined with half-finished tenements, for what must once have been the most beautiful of Genoese pleasure-houses—the Villa Imperiali, probably built by Fra Montorsoli. It stands high above broad terraced grounds of unusual extent, backed by a hanging wood; but all the old gardens have been destroyed, save the beautiful upper terrace, and even the house has suffered some injury, though not enough to detract greatly from its general effect. Here at last one finds that union of lightness and majesty which characterizes the Villa Medici and other Roman houses of its kind. The long elevation, with wings set back, has a rusticated basement, surmounted by two stories and an attic above the cornice. There is no order, but the whole façade is richly frescoed in a severe architectural style, with

niches, statues in grisaille, and other ornaments, all executed by a skilful hand. The windows on the first floor have broken pediments with a shell-like movement, and those above show the same treatment, alternating with the usual triangular pediment. But the crowning distinction of the house consists in the two exquisite loggias which form the angles of the second story. These tall arcades, resting on slender columns, give a wonderful effect of spreading lightness to the façade, and break up its great bulk without disturbing the general impression of strength and dignity. As a skilful distribution of masses the elevation of the Villa Imperiali deserves the most careful study, and it is to be regretted that it can no longer be seen in combination with the wide-spread terraces which once formed a part of its composition.

LOMBARD VILLAS

VI

LOMBARD VILLAS

O N the walls of the muniment-room of the old Borromeo palace in Milan, Michelino, a little-known painter of the fifteenth century, has depicted the sports and diversions of that noble family. Here may be seen ladies in peaked hennins and long drooping sleeves, with their shock-headed gallants in fur-edged tunics and pointed shoes, engaged in curious games and dances, against the background of Lake Maggiore and the Borromean Islands.

It takes the modern traveller an effort of mental read-justment to recognize in this " clump of peakèd isles "— bare Leonardesque rocks thrusting themselves splinter-wise above the lake—the smiling groves and terraces of the Isola Bella and the Isola Madre. For in those days the Borromei had not converted their rocky islands into the hanging gardens which to later travellers became one of thé most important sights of the " grand tour "; and one may learn from this curious fresco with what seemingly hopeless problems the Italian garden-art dealt, and how, while audaciously remodelling nature, it con-trived to keep in harmony with the surroundings amid which it worked.

The Isola Madre, the largest of the Borromean group, was the first to be built on and planted. The plain Renaissance palace still looks down on a series of walled gardens and a grove of cypress, laurel and pine; but the greater part of the island has been turned into an English park of no special interest save to the horticulturist, who may study here the immense variety of exotic plants which flourish in the mild climate of the lakes. The Isola Bella, that pyramid of flower-laden terraces rising opposite Stresa, in a lovely bend of the lake, began to take its present shape about 1632, when Count Carlo III built a *casino di delizie* on the rocky pinnacle. His son, Count Vitaliano IV, continued and completed the work. He levelled the pointed rocks, filled their interstices with countless loads of soil from the mainland, and summoned Carlo Fontana and a group of Milanese architects to raise the palace and garden-pavilions above terraces created by Castelli and Crivelli, while the waterworks were entrusted to Mora of Rome, the statuary and other ornamental sculpture to Vismara. The work was completed in 1671, and the island, which had been created a baronial fief, was renamed Isola Isabella, after the count's mother—a name which euphony, and the general admiration the place excited, soon combined to contract to Isola Bella.

The island is built up in ten terraces, narrowing successively toward the top, the lowest resting on great vaulted arcades which project into the lake and are used

as a winter shelter for the lemon-trees of the upper gardens. Each terrace is enclosed in a marble balustrade, richly ornamented with vases, statues and obelisks, and planted with a profusion of roses, camellias, jasmine, myrtle and pomegranate, among which groups of cypresses lift their dark shafts. Against the retaining-walls oranges and lemons are espaliered, and flowers border every path and wreathe every balustrade and stairway. It seems probable, from the old descriptions of the Isola Bella, that it was originally planted much as it now appears; in fact, the gardens of the Italian lakes are probably the only old pleasure-grounds of Italy where flowers have always been used in profusion. In the equable lake climate, neither cold in winter, like the Lombard plains, nor parched in summer, like the South, the passion for horticulture seems to have developed early, and the landscape-architect was accustomed to mingle bright colours with his architectural masses, instead of relying on a setting of uniform verdure.

The topmost terrace of the Isola Bella is crowned by a mount, against which is built a water-theatre of excessively baroque design. This architectural composition faces the southern front of the palace, a large and not very interesting building standing to the north of the gardens; while the southern extremity of the island terminates in a beautiful garden-pavilion, hexagonal in shape, with rusticated coigns and a crowning balustrade beset with statues. Even the narrow reef projecting

into the lake below this pavilion has been converted into another series of terraces, with connecting flights of steps, which carry down to the water's edge the exuberant verdure of the upper gardens.

The palace is more remarkable for what it contains in the way of furniture and decoration than for any architectural value. Its great bulk and heavy outline are quite disproportionate to the airy elegance of the gardens it overlooks, and house and grounds seem in this case to have been designed without any regard to each other. The palace has, however, one feature of peculiar interest to the student of villa-architecture, namely, the beautiful series of rooms in the south basement, opening on the gardens, and decorated with the most exquisite ornamentation of pebble-work and sea-shells, mingled with delicately tinted stucco. These low vaulted rooms, with marble floors, grotto-like walls, and fountains dripping into fluted conchs, are like a poet's notion of some twilight refuge from summer heats, where the languid green air has the coolness of water; even the fantastic consoles, tables and benches, in which cool-glimmering mosaics are combined with carved wood and stucco painted in faint greens and rose-tints, might have been made of mother-of-pearl, coral and seaweed for the adornment of some submarine palace. As examples of the decoration of a garden-house in a hot climate, these rooms are unmatched in Italy, and their treatment offers appropriate suggestions

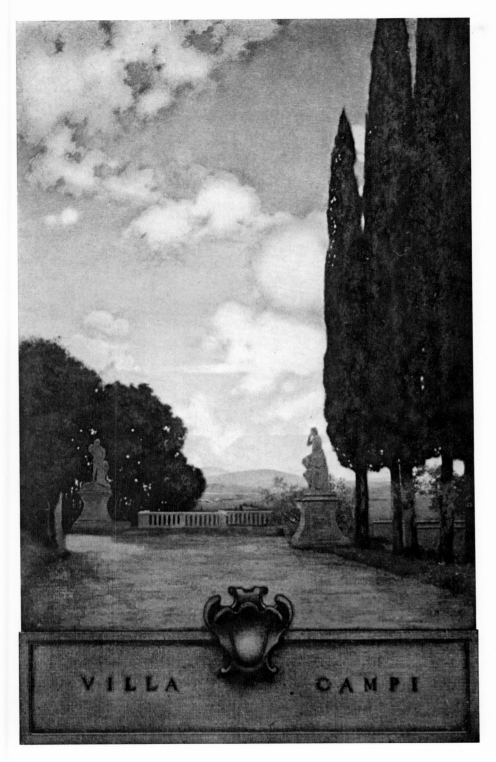

VILLA CAMPI, NEAR FLORENCE

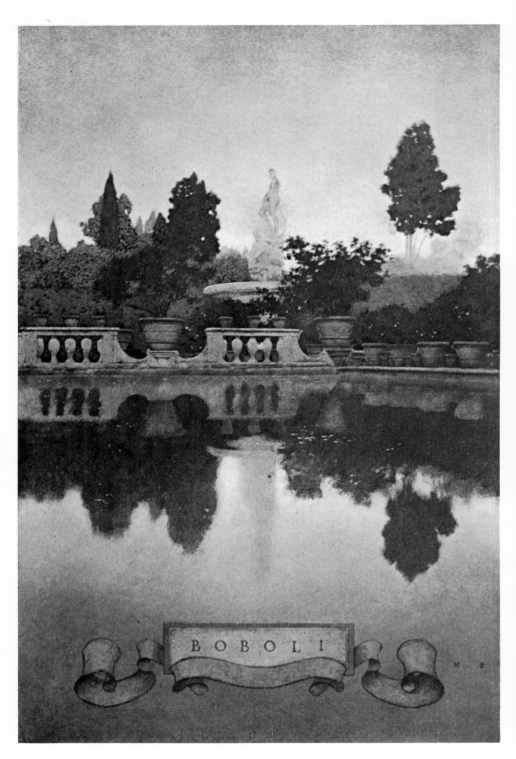

BOBOLI GARDEN, FLORENCE

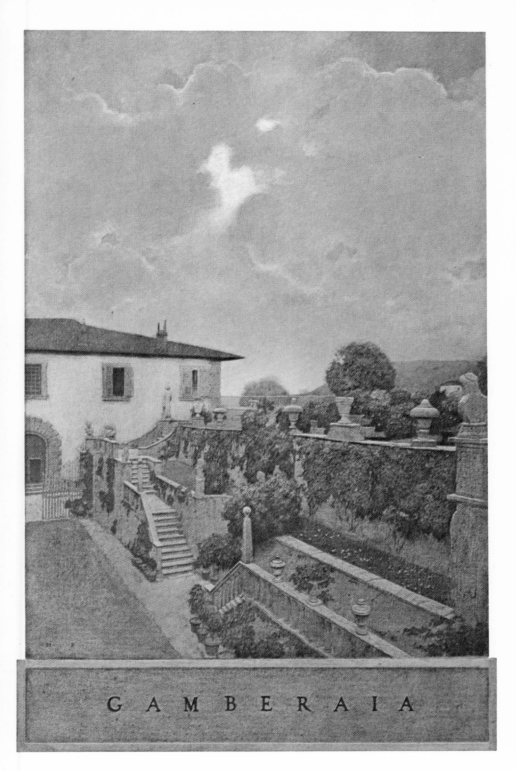

VILLA GAMBERAIA, NEAR FLORENCE

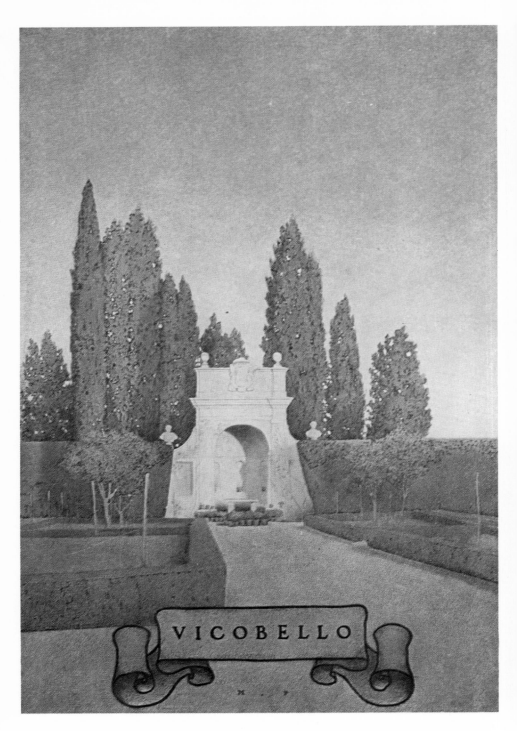

VICOBELLO, SIENA

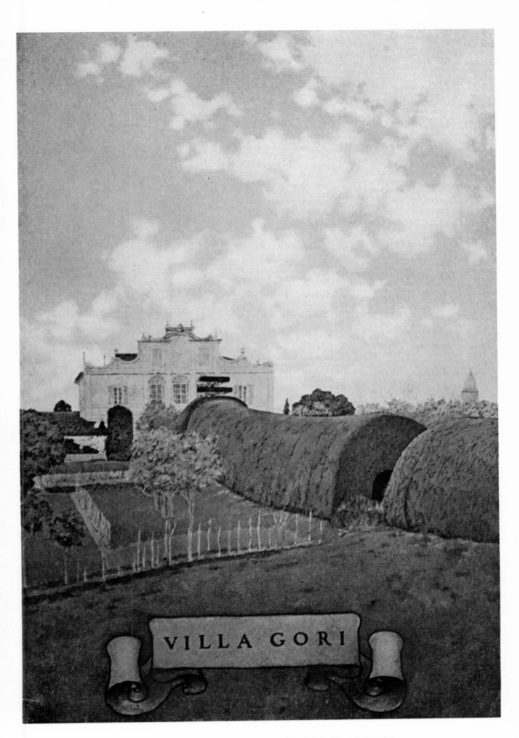

LA PALAZZINA (VILLA GORI), SIENA

THE THEATRE AT LA PALAZZINA, SIENA

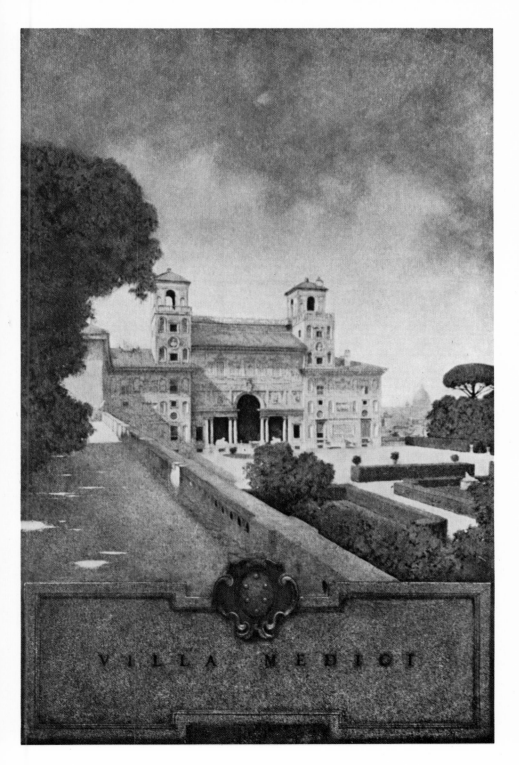

VILLA MEDICI, ROME

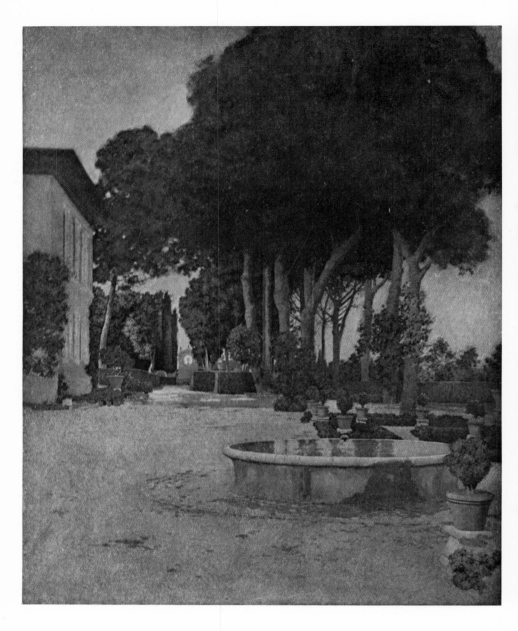

VILLA CHIGI

VILLA CHIGI, ROME

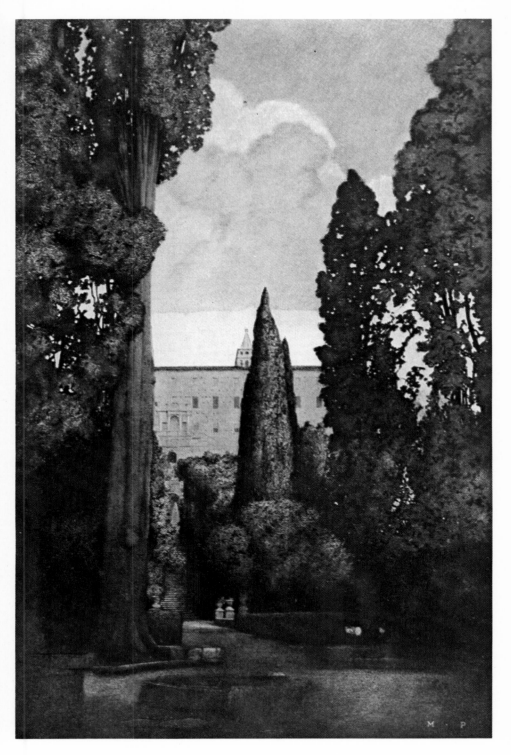

VILLA D'ESTE, TIVOLI

THE POOL, VILLA D'ESTE, TIVOLI

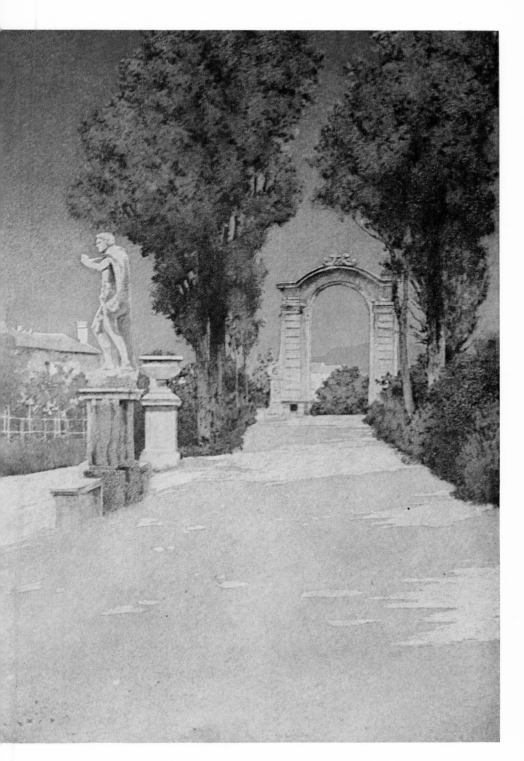

VILLA SCASSI, GENOA

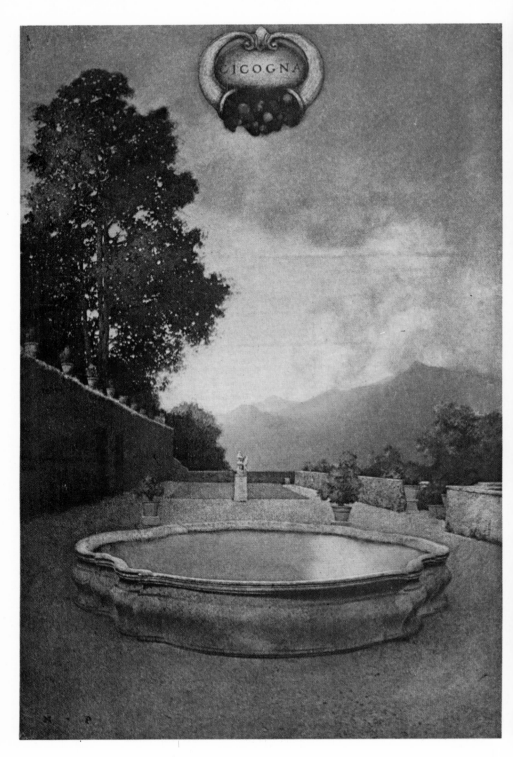

VILLA CICOGNA, BISUSCHIO

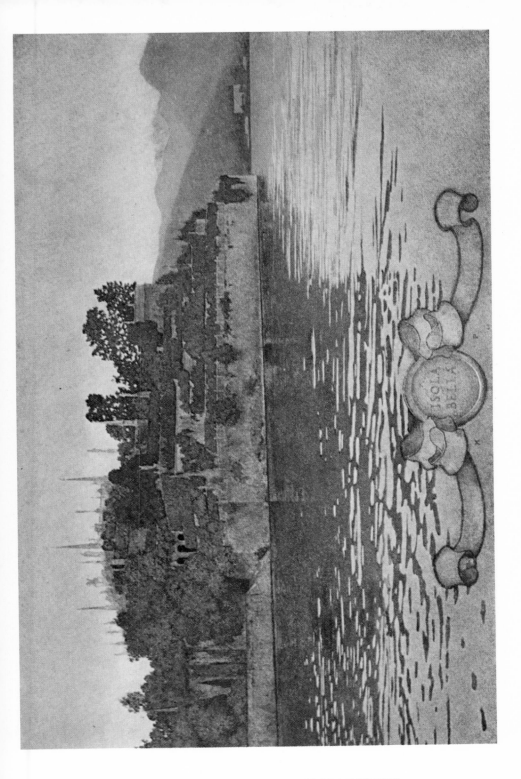

VILLA ISOLA BELLA, LAKE MAGGIORE

IN THE GARDENS OF ISOLA BELLA, LAKE MAGGIORE

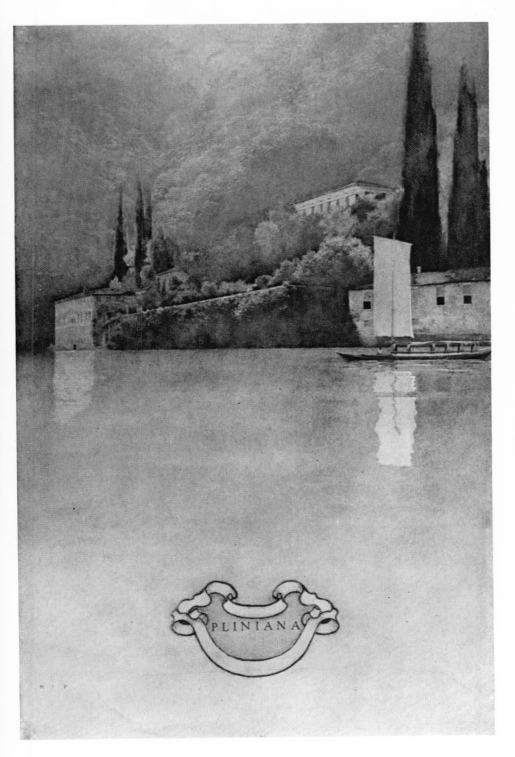

VILLA PLINIANA, LAKE COMO

to the modern garden-architect in search of effects of coolness.

To show how little the gardens of the Isola Bella have been changed since they were first laid out, it is worth while to quote the description of Bishop Burnet, that delightful artist in orthography and punctuation, who descended into Italy in the year 1685, with his "portmangles" laden upon "mullets."

"From *Lugane*," the bishop's breathless periods begin, "I went to the *Lago Maggiore*, which is a great and noble Lake, it is six and fifty Miles long, and in most places six Miles broad, and a hundred Fathoms deep about the middle of it, it makes a great Bay to the Westward, and there lies here two Islands called the *Borromean* Islands, that are certainly the loveliest spots of ground in the World, there is nothing in all Italy that can be compared to them, they have the full view of the Lake, and the ground rises so sweetly in them that nothing can be imagined like the Terraces here, they belong to two Counts of the *Borromean* family. I was only in one of them, which belongs to the head of the Family, who is Nephew to the famous Cardinal known by the name of St *Carlo* . . . The whole Island is a garden . . . and because the figure of the Island was not made regular by Nature, they have built great Vaults and Portica's along the Rock, which are all made Grotesque, and so they have brought it into a regular form by laying earth over those Vaults. There

17

is first a Garden to the East that rises up from the Lake
by five rows of Terrasses, on the three sides of the Gar-
den that are watered by the Lake, the Stairs are noble,
the Walls are all covered with Oranges and Citrons, and a
more beautiful spot of a Garden cannot be seen: There
are two buildings in the two corners of this Garden, the
one is only a Mill for fetching up the Water, and the
other is a noble Summer-House [the hexagonal pavil--
ion] all Wainscotted, if I may speak so, with Alabaster
and Marble of a fine colour inclining to red, from this
Garden one goes in a level to all the rest of the Alleys
and Parterres, Herb-Gardens and Flower-Gardens, in
all which there are Varieties of Fountains and Ar-
bors, but the great Parterre is a surprizing thing, for as
it is well furnished with Statues and Fountains, and is
of a vast extent, and justly scituated to the Palace, so at
the further-end of it there is a great Mount, that face of
it that looks to the Parterre is made like a Theatre all
full of Fountains and Statues, the height rising up in five
several rows . . . and round this Mount, answering to
the five rows into which the Theatre is divided, there goes
as Many Terrasses of noble Walks, the Walls are all as
close covered with Oranges and Citrons as any of our
Walls in *England* are with Laurel: the top of the Mount
is seventy foot long and forty broad, and here is a vast
Cestern into which the Mill plays up the water that must
furnish all the Fountains . . . The freshness of the Air,
it being both in a Lake and near the Mountains, the

fragrant smell, the beautiful Prospect, and the delighting Variety that is here makes it such a habitation for Summer that perhaps the whole World hath nothing like it."

Seventeenth-century travellers were unanimous in extolling the Isola Bella, though, as might have been expected, their praise was chiefly for those elaborations and ingenuities of planning and engineering which give least pleasure in the present day. Toward the middle of the eighteenth century a critical reaction set in. Tourists, enamoured of the new " English garden," and of Rousseau's descriptions of the "bosquet de Julie," could see nothing to admire in the ordered architecture of the Borromean Islands. The sentimental sight-seer, sighing for sham Gothic ruins, for glades planted "after Poussin," and for all the laboured naturalism of Repton and Capability Brown, shuddered at the frank artifice of the old Italian garden-architecture. The quarrel then begun still goes on, and sympathies are divided between the artificial-natural and the frankly conventional. The time has come, however, when it is recognized that both these manners *are* manners, the one as artificial as the other, and each to be judged, not by any ethical standard of " sincerity," but on its own æsthetic merits. This has enabled modern critics to take a fairer view of such avowedly conventional compositions as the Isola Bella, a garden in comparison with which the grounds of the great Roman villas are as naturalistic as the age of Rousseau could have desired.

Thus impartially judged, the Isola Bella still seems to many too complete a negation of nature; nor can it appear otherwise to those who judge of it only from pictures and photographs, who have not seen it in its environment. For the landscape surrounding the Borromean Islands has precisely that quality of artificiality, of exquisitely skilful arrangement and manipulation, which seems to justify, in the garden-architect, almost any excesses of the fancy. The Roman landscape, grandiose and ample, seems an unaltered part of nature; so do the subtly modelled hills and valleys of central Italy: all these scenes have the deficiencies, the repetitions, the meannesses and profusions, with which nature throws her great masses on the canvas of the world; but the lake scenery appears to have been designed by a lingering and fastidious hand, bent on eliminating every crudeness and harshness, and on blending all natural forms, from the bare mountain-peak to the melting curve of the shore, in one harmony of ever-varying and ever-beautiful lines.

The effect produced is undoubtedly one of artificiality, of a chosen exclusion of certain natural qualities, such as gloom, barrenness, and the frank ugliness into which nature sometimes lapses. There is an almost forced gaiety about the landscape of the lakes, a fixed smile of perennial loveliness. And it is as a complement to this attitude that the Borromean gardens justify themselves. Are they real? No; but neither is the landscape about

them. Are they like any other gardens on earth? No; but neither are the mountains and shores about them like earthly shores and mountains. They are Armida's gardens anchored in a lake of dreams, and they should be compared, not with this or that actual piece of planted ground, but with a page of Ariosto or Boiardo.

From the garden-student's point of view, there is nothing in Lombardy as important as the Isola Bella. In these rich Northern provinces, as in the environs of Florence, the old gardens have suffered from the affluence of their owners, and scarcely any have been allowed to retain their original outline. The enthusiasm for the English garden swept over Lombardy like a tidal wave, obliterating terraces and grottoes, substituting winding paths for pleached alleys, and transforming level box-parterres into rolling lawns which turn as brown as door-mats under the scorching Lombard sun.

On the lakes, where the garden-architect was often restricted to a narrow ledge of ground between mountains and water, these transformations were less easy, for the new style required a considerable expanse of ground for its development. Along the shores of Como especially, where the ground rises so abruptly from the lake, landscape effects were difficult to produce, nor was it easy to discover a naturalistic substitute for the marble terraces built above the water. Even here, however, the narrow gardens have been as much modified as

space permitted, the straight paths have been made to wind, and spotty flower-beds in grass have replaced the ordered box-gardens with their gravelled walks and their lemon-trees in earthen vases.

The only old garden on Como which keeps more than a fragment of its original architecture is that of the Villa d'Este at Cernobbio, a mile or two from the town of Como, at the southern end of the lake. The villa, built in 1527 by Cardinal Gallio (who was born a fisher-lad of Cernobbio), has passed through numerous transformations. In 1816 it was bought by Caroline of Brunswick, who gave it the name of Este, and turned it into a great structure of the Empire style. Here for several years the Princess of Wales held the fantastic court of which Bergami, the courier, was High Chamberlain if not Prince Consort; and, whatever disadvantages may have accrued to herself from this establishment, her residence at the Villa d'Este was a benefit to the village, for she built the road connecting Cernobbio with Moltrasio, which was the first carriage-drive along the lake, and spent large sums on improvements in the neighbourhood of her estate.

Since then the villa has suffered a farther change into a large and fashionable hotel; but though Queen Caroline anglicized a part of the grounds, the main lines of the old Renaissance garden still exist.

Behind the Villa d'Este the mountains are sufficiently withdrawn to leave a gentle acclivity, which was

once laid out in a series of elaborate gardens. Adjoining the villa is a piece of level ground just above the lake, which evidently formed the "secret garden" with its parterres and fountains. This has been replaced by a lawn and flower-beds, but still keeps its boundary-wall at the back, with a baroque grotto and fountain of pebbles and shell-work. Above this rises a *tapis vert* shaded by cypresses, and leading to the usual Hercules in a temple. The peculiar feature of this ascent is that it is bordered on each side with narrow steps of channelled stone, down which the water rushes under overlapping ferns and roses to the fish-pool below the grotto in the lower garden. Beyond the formal gardens is the *bosco*, a bit of fine natural woodland climbing the cliff-side, with winding paths which lead to various summer-houses and sylvan temples. The rich leafage of walnut, acacia and cypress, the glimpses of the blue lake far below, the rush of a mountain torrent through a deep glen spanned by a romantic ivy-clad bridge, make this *bosco* of the Villa d'Este one of the most enchanting bits of sylvan gardening in Italy. Scarcely less enchanting is the grove of old plane-trees by the water-gate on the lake, where, in a solemn twilight of over-roofing branches, woodland gods keep watch above the broad marble steps descending to the water. In the gardens of the Villa d'Este there is much of the Roman spirit—the breadth of design, the unforced inclusion of natural features, and that sensitiveness to the quality

of the surrounding landscape which characterizes the great gardens of the Campagna.

Just across the lake, in the deep shade of the wooded cliffs beneath the Pizzo di Torno, lies another villa still more steeped in the Italian garden-magic. This is the Villa Pliniana, built in 1570 by the Count Anguissola of Piacenza, and now the property of the Trotti family of Milan. The place takes its name from an intermittent spring in the court, which is supposed to be the one described by Pliny in one of his letters; and it is farther celebrated as being the coolest villa on Como. It lies on a small bay on the east side of the lake, and faces due north, so that, while the villas of Cernobbio are bathed in sunlight, a deep green shade envelops it. The house stands on a narrow ledge, its foundations projecting into the lake, and its back built against the almost vertical wooded cliff which protects it from the southern sun. Down this cliff pours a foaming mountain torrent from the Val di Calore, just beneath the peak of Torno; and this torrent the architect of the Villa Pliniana has captured in its descent to the lake and carried through the central apartment of the villa.

The effect produced is unlike anything else, even in the wonderland of Italian gardens. The two wings of the house, a plain and somewhat melancholy-looking structure, are joined by an open arcaded room, against the back wall of which the torrent pours down, over stonework tremulous with moss and ferns, gushing

out again beneath the balustrade of the loggia, where it makes a great semicircle of glittering whiteness in the dark-green waters of the lake. The old house is saturated with the freshness and drenched with the flying spray of the caged torrent. The bare vaulted rooms reverberate with it, the stone floors are green with its dampness, the air quivers with its cool incessant rush. The contrast of this dusky dripping loggia, on its perpetually shaded bay, with the blazing blue waters of the lake and their sun-steeped western shores, is one of the most wonderful effects in *sensation* that the Italian villa-art has ever devised.

The architect, not satisfied with diverting a part of the torrent to cool his house, has led the rest in a fall down the cliff immediately adjoining the villa, and has designed winding paths through the woods from which one may look down on the bright rush of the waters. On the other side of the house lies a long balustraded terrace, between the lake and the hanging woods, and here, on the only bit of open and level ground near the house, are the old formal gardens, now much neglected, but still full of a melancholy charm.

After the Villa Pliniana, the other gardens of Como seem almost commonplace. All along both shores are villas which, amid many alterations, have preserved traces of their old garden-architecture, such as the Bishop of Como's villa, south of Leno, with its baroque saints and prophets perched along the garden-balus-

trade, and the more famous Villa Carlotta at Cadenabbia, where the fine gateways and the architectural treatment of the terraces bear witness to the former beauty of the grounds. But almost everywhere the old garden-magic has been driven out by a fury of modern horticulture. The pleached alleys have made way for lawns dotted with palms and bananas, the box-parterres have been replaced by star-shaped beds of begonias and cinerarias, and the groves of laurel and myrtle by thickets of pampas-grass and bamboo. This description applies to all the principal gardens between Como and Bellagio. Here and there, indeed, in almost all of them, some undisturbed corner remains—a flight of steps wreathed in Banksian roses and descending to a shady water-gate; a fern-lined grotto with a stucco Pan or Syrinx; a clipped laurel-walk set with marble benches, or a classic summer-house above the lake— but these old bits are so scattered and submerged under the new order of gardening that it requires an effort of the imagination to reconstruct from them an image of what the old lake-gardens must have been before every rich proprietor tried to convert his marble terraces into an English park.

Almost to be included among lake-villas is the beautiful Villa Cicogna at Bisuschio. This charming old place lies in the lovely but little-known hill-country between the Lake of Varese and the southern end of Lugano. The house, of which the history appears to

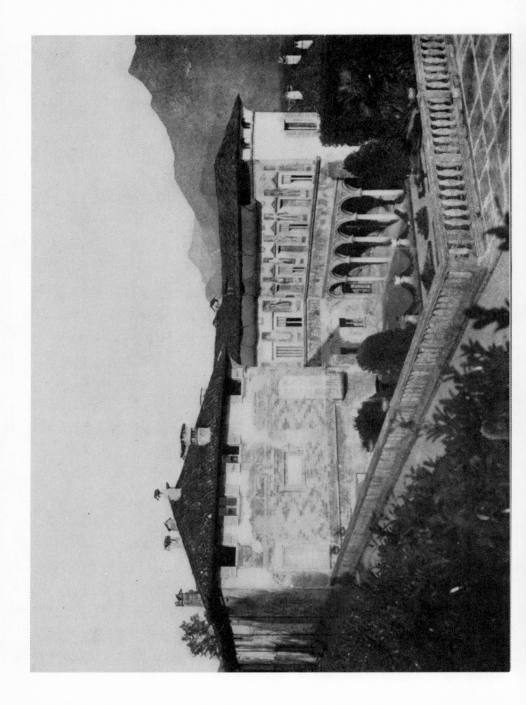

VILLA CICOGNA, FROM THE TERRACE ABOVE THE HOUSE

be unknown to the present owners, is an early Renaissance building of great beauty, with a touch of Tuscan austerity in its design. The plain front, with deep projecting eaves and widely spaced windows, might stand on some village square above the Arno ; and the interior court, with its two-storied arcade, recalls, in purity and lightness of design, the inheritors of Brunelleschi's tradition. So few country houses of the early sixteenth century are to be found in the Milanese that it would be instructive to learn whether the Villa Cicogna is in fact due to a Tuscan hand, or whether this mid-Italian style was at that time also prevalent in Lombardy.

The villa is built against a hillside, and the interior court forms an oblong, enclosed on three sides by the house, and continued on the fourth by a beautiful sunken garden, above which runs a balustraded walk on a level with the upper story. On the other side of the house is another garden, consisting of a long terrace bounded by a high retaining-wall, which is tunnelled down its whole length to form a shady arcaded walk lined with ferns and dripping with runnels of water. At the back of the house the ground continues to rise, and a *château d'eau* is built against the hillside; while beyond the terrace-garden already described, a gate leads to a hanging woodland, with shady walks from which, at every turn, there are enchanting views across the southern bay of Lake Lugano.

The house itself is as interesting as the garden. The

walls of the court are frescoed in charming cinque-cento designs, and the vaulted ceiling of the loggia is painted in delicate trellis-work, somewhat in the manner of the semicircular arcade at the Villa di Papa Giulio. Several of the rooms also preserve their wall-frescoes and much of their Renaissance furniture, while a series of smaller apartments on the ground floor are exquisitely decorated with stucco ornament in the light style of the eighteenth century; so that the Villa Cicogna still gives a vivid idea of what an old Italian country house must have been in its original state.

From the hill-villas of the lakes to the country places of the Milanese rice-fields the descent is somewhat abrupt; but the student of garden-architecture may mitigate the transition by carrying on his researches from the southern end of Como through the smiling landscape of the Brianza. Here there are many old villas, in a lovely setting of vineyard and woodland, with distant views of the Alps and of the sunny Lombard plain; but of old gardens few are to be found. There is one of great beauty, belonging to the Villa Crivelli, near the village of Inverigo ; but as it is inaccessible to visitors, only tantalizing glimpses may be obtained of its statues and terraces, its cypress-walks and towering " Gigante." Not far from Inverigo is the Rotonda Cagnola, now the property of the Marchese d'Adda, and built in 1813 by the Marchese Luigi Cagnola in imitation of the Propylæa of the Acropolis. The house is beautifully placed on a hilltop,

with glorious views over the Alps and Apennines, and is curious to the student as an example of the neo-classicism of the Empire; but it has of course no gardens in the old sense of the term.

The flat environs of Milan were once dotted with country houses, but with the growth of the city and the increased facilities of travel, these have been for the most part abandoned for villas in the hills or on the lakes, and to form an idea of their former splendour one must turn to the pages of Alberto del Rè's rare volumes. Here one may see in all its detail that elaborate style of gardening which the French landscape-gardeners developed from the " grand manner" acquired by Le Nôtre in his study of the great Roman country-seats. This style, adapted to the flat French landscape, and complicated by the mannerisms and elaborations of the eighteenth century, came back to Italy with the French fashions which Piedmont and Lombardy were so fond of importing. The time had passed when Europe modelled itself on Italy: France was now the glass of fashion, and, in northern Italy especially, French architecture and gardening were eagerly reproduced.

In Lombardy the natural conditions were so similar that the French geometrical gardens did not seem out of place; yet even here a difference is felt, both in the architecture and the gardens. Italy, in spite of Palladio and the Palladian tradition, never freed herself from the baroque. Her artistic tendencies were all toward free-

dom, improvisation, individual expression, while France was fundamentally classical and instinctively temperate. Just as the French cabinet-makers and bronze-chisellers and modellers in stucco produced more delicate and finished, but less personal, work than the Italian craftsmen, so the French architects designed with greater precision and restraint, and less play of personal invention. To establish a rough distinction, it might be said that French art has always been intellectual and Italian art emotional; and this distinction is felt even in the treatment of the pleasure-house and its garden. In Italy the architectural detail remained baroque till the end of the eighteenth century, and the architect permitted himself far greater license in the choice of forms and the combination of materials. The old villas of the Milanese have a very strong individuality, and it is to be regretted that so few remain intact to show what a personal style they preserved even under the most obvious French influences.

The Naviglio, the canal which flows through Milan and sends various branches to the Ticino and the Adda, was formerly lined for miles beyond the city with suburban villas. Few remain unaltered, and even of these few the old gardens have disappeared. One of the most interesting houses in Del Rè's collection, the Villa Alario (now Visconti di Saliceto), on the Naviglio near Cernusco, is still in perfect preservation without and within; and though its old gardens were replaced by an English park early in the nineteenth century, their general outline is

still discoverable. The villa, a stately pile built by Ruggieri in 1736, looks on a court divided from the highway by a fine wall and beautiful iron gates. Low wings containing the chapel and offices, and running at right angles to the main building, connect the latter with the courtyard walls; and arched passages through the centre of the wings lead to outlying courts surrounded by stables and other dependencies. The house, toward the forecourt, has a central open loggia or atrium, and the upper windows are framed 'in baroque architraves and surmounted by square attic lights. The garden elevation is more elaborate. Here there is a central projection, three windows wide, flanked by two-storied open loggias, and crowned by an attic with ornamental pilasters and urns. This central bay is adorned with beautiful wrought-iron balconies, which are repeated in the wings at each end of the building. All the wrought-iron of the Villa Visconti is remarkable for its elegance and originality, and as used on the terraces, and in the balustrade of the state staircase, in combination with heavy baroque stone balusters, it is an interesting example of a peculiarly Lombard style of decoration.

Between the house and the Naviglio there once lay an elaborate *parterre de broderie*, terminated above the canal by a balustraded retaining-wall adorned with statues, and flanked on each side by pleached walks, arbours, trellis-work and fish-ponds. Of this complicated plea-

sance little remains save the long terraces extending from each end of the house, the old flower-garden below one of these, and some bits of decorative sculpture incorpo-

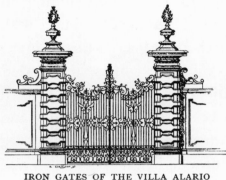

IRON GATES OF THE VILLA ALARIO
(NOW VISCONTI DI SALICETO)

rated in the boundary-walls. The long tank or canal shown in Del Rè's print has been turned into an irregular pond with grass-banks, and the *parterre de broderie* is now a lawn; even the balustrade has been re-moved from the wall along the Naviglio. Still, the ar-chitectural details of the forecourt and the terraces are worthy of careful study, and the unusual beauty of the old villa, with its undisturbed group of dependencies, partly atones for the loss of its original surroundings.

Many eighteenth-century country houses in the style of the Villa Visconti are scattered through the Milanese, though few have retained so unaltered an outline, or even such faint traces of their formal gardens. The huge villa of the Duke of Modena at Varese—now the Municipio—is a good example of the same architecture, and has a beautiful stone-and-iron balustrade and many wrought-iron balconies in the same style as those at Cernusco; and its gardens, ascending the hillside behind the house, and now used as a public park, must once have been very fine. The Grand Hôtel of Varese is

also an old villa, and its architectural screen and projecting wings form an unusually characteristic façade of the same period. Here, again, little remains of the old garden but a charming upper terrace; but the interior decorations of many of the rooms are undisturbed, and are exceptionally interesting examples of the more delicate Italian baroque.

Another famous country house, Castellazzo d'Arconate, at Bollate, is even more palatial than the Duke of Modena's villa at Varese, and, while rather heavy in general outline, has an interesting interior façade, with a long arcade resting on coupled columns, and looking out over a stately courtyard with statues. This villa is said to have preserved a part of its old gardens, but it is difficult of access, and could not be visited at the time when the material for these chapters was collected.

RAILING OF THE VILLA ALARIO

VILLAS OF VENETIA

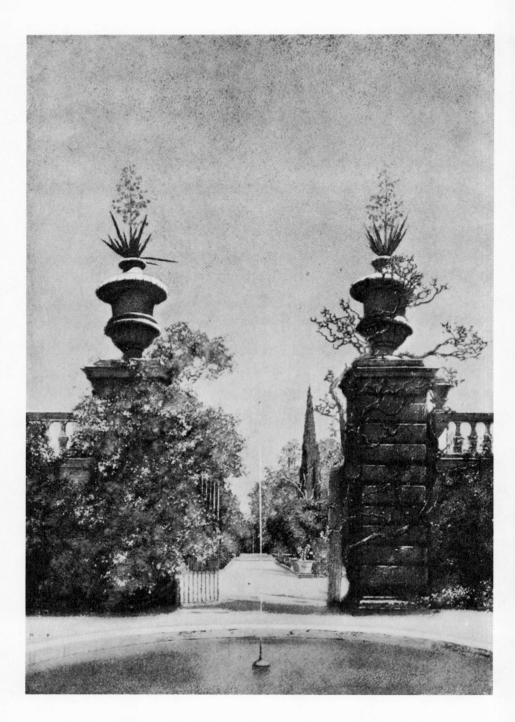

GATEWAY OF THE BOTANIC GARDEN, PADUA

VII

VILLAS OF VENETIA

WRITERS on Italian architecture have hitherto paid little attention to the villa-architecture of Venetia. It is only within the last few years that English and American critics have deigned to recognize any architectural school in Italy later than that of Vignola and Palladio, and even these two great masters of the sixteenth century have been held up as examples of degeneracy to a generation bred in the Ruskinian code of art ethics. In France, though the influence of Viollet-le-Duc was nearly as hostile as Ruskin's to any true understanding of Italian art, the Latin instinct for form has asserted itself in a revived study of the classic tradition; but French writers on architecture have hitherto confined themselves chiefly to the investigation of their national styles.

It is only in Germany that Italian architecture from Palladio to Juvara has received careful and sympathetic study. Burckhardt pointed the way in his "Cicerone" and in " The Architecture of the Renaissance in Italy "; Herr Gustav Ebe followed with an interesting book on the late Renaissance throughout Europe; and Herr

Gurlitt has produced the most masterly work yet written on the subject, his " History of the Baroque Style in Italy." These authors, however, having to work in a new and extensive field, have necessarily been obliged to restrict themselves to its most important divisions. Burckhardt's invaluable " Renaissance Architecture," though full of critical insight, is rather a collection of memoranda than a history of the subject; and even Herr Gurlitt, though he goes into much greater detail, cannot forsake the highroad for the by-paths, and has consequently had to pass by many minor ramifications of his subject. This is especially to be regretted in regard to the villa-architecture of Venetia, the interest and individuality of which he fully appreciates. He points out that the later Venetian styles spring from two sources, the schools of Palladio and of Sansovino. The former, greatly as his work was extolled, never had the full sympathy of the Venetians. His art was too pure and severe for a race whose taste had been formed on the fantastic mingling of Gothic and Byzantine and on the glowing decorations of the greatest school of colourists the world has known. It was from the warm and picturesque art of Sansovino and Longhena that the Italian baroque naturally developed; and though the authority of Palladio made itself felt in the official architecture of Venetia, its minor constructions, especially the villas and small private houses, seldom show any trace of his influence save in the grouping of their win-

dows. So little is known of the Venetian villa-builders that this word as to their general tendencies must replace the exact information which still remains to be gathered.

Many delightful examples of the Venetian *maison de plaisance* are still to be found in the neighbourhood of Padua and Treviso, along the Brenta, and in the country between the Euganeans and the Monti Berici. Unfortunately, in not more than one or two instances have the old gardens of these houses been preserved in their characteristic form; and, by a singular perversity of fate, it happens that the villas which have kept their gardens are not typical of the Venetian style. One of them, the castle of Cattajo, at Battaglia in the Euganean Hills, stands in fact quite apart from any contemporary style. This extraordinary edifice, built for the Obizzi of Venice about 1550, is said to have been copied from the plans of a castle in Tartary brought home by Marco Polo. It shows, at any rate, a deliberate reversion, in mid-cinque-cento, to a kind of Gothicism which had become obsolete in northern Italy three hundred years earlier; and the mingling of this rude style with classic detail and Renaissance sculpture has produced an effect picturesque enough to justify so quaint a tradition.

Cattajo stands on the edge of the smiling Euganean country, its great fortress-like bulk built up against a wooded knoll with a little river at its base. Crossing the river by a bridge flanked by huge piers surmounted with statues, one reaches a portcullis in a massive gate-

house, also adorned with statues. The portcullis opens on a long narrow court planted with a hedge of clipped euonymus ; and at one end a splendid balustraded stairway *à cordon* leads up to a flagged terrace with yew-trees growing between the flags. To the left of this terrace is a huge artificial grotto, with a stucco Silenus lolling on an elephant, and other life-size animals and figures, a composition recalling the zoölogical wonders of the grotto at Castello. This Italian reversion to the grotesque, at a time when it was losing its fascination for the Northern races, might form the subject of an interesting study of race æsthetics. When the coarse and sombre fancy of mediæval Europe found expression in grinning gargoyles and baleful or buffoonish images, Italian art held serenely to the beautiful, and wove the most tragic themes into a labyrinth of lovely lines; but in the seventeenth and eighteenth centuries, when the classical graces had taken possession of northern Europe, the chimerical animals, the gnomes and goblins, the gargoyles and broomstick-riders, fled south of the Alps, and reappeared in the queer fauna of Italian grottoes and in the leering dwarfs and satyrs of the garden-walk.

From the yew-tree terrace at Cattajo an arcaded loggia gives access to the interior of the castle, which is a bewilderment of low-storied passageways and long flights of steps hewn in the rock against which the castle is built. From a vaulted tunnel of stone one passes abruptly into a suite of lofty apartments decorated

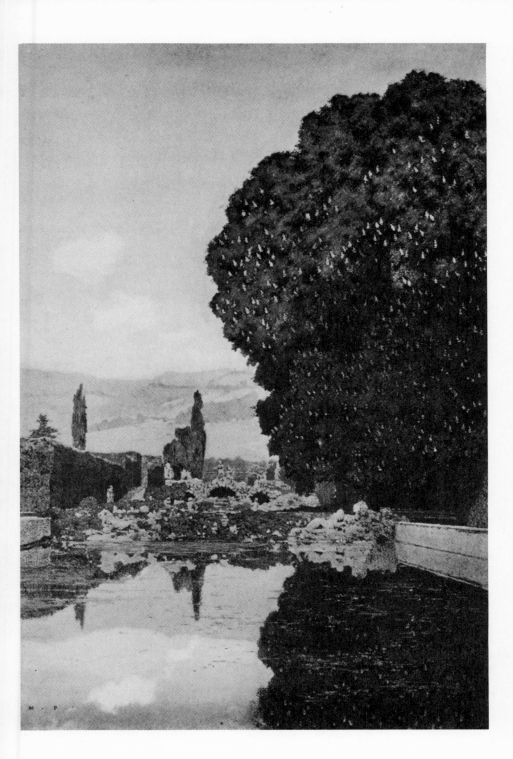

VIEW AT VAL SAN ZIBIO, NEAR BATTAGLIA

with seventeenth-century frescoes and opening on a balustraded terrace guarded by marble divinities; or, taking another turn, one finds one's self in a sham Gothic chapel or in a mediæval *chemin de ronde* on the crenelated walls. This fantastic medley of styles, in conjunction with the unusual site of the castle, has produced several picturesque bits of garden, wedged between the walls and the hillside, or on the terraces overhanging the river; but from the architectural point of view, the most interesting thing about Cattajo is the original treatment of the great stairway in the court.

Six or seven miles from Battaglia, in a narrow and fertile valley of the Euganeans, lies one of the most beautiful pleasure-grounds in Italy. This is the garden of the villa at Val San Zibio. On approaching it, one sees, across a grassy common, a stately and ornate arch of triumph with a rusticated façade and a broken pediment enriched with statues. This arch, which looks as though it were the principal entrance-gate, appears to have been placed in the high boundary-wall merely in order to afford from the highway a vista of the *château d'eau* which is the chief feature of the gardens. The practice of breaking the wall to give a view of some special point in the park or garden was very common in France, but is seldom seen in Italy, though there is a fine instance of it in the open grille below the Villa Aldobrandini at Frascati.

The house at Val San Zibio is built with its back to

the highroad, and is an unpretentious structure of the seventeenth century, not unlike the Villa de' Gori at Siena, though the Palladian grouping of its central windows shows the nearness of Venice. It looks on a terrace enclosed by a balustrade, whence a broad flight of steps descends to the gently sloping gardens. They are remarkable for their long pleached alleys of beech, their wide *tapis verts*, fountains, marble benches and statues charmingly placed in niches of clipped verdure. In one direction is a little lake, in another a "mount" crowned by a statue, while a long alley leads to a well-preserved maze with a raised platform in its centre. These labyrinths are now rarely found in Italian gardens, and were probably never as popular south of the Alps as in Holland and England. The long *château d'eau*, with its couchant Nereids and conch-blowing Tritons, descends a gentle slope instead of a steep hill, and on each side high beech-hedges enclose tall groves of deciduous trees. These hedges are characteristic of the north Italian gardens, where the plane, beech and elm replace the "perennial greens" of the south ; and there is one specially charming point at Val San Zibio, where four grass-alleys walled with clipped beeches converge on a stone basin sunk in the turf, with four marble putti seated on the curb, dangling their feet in the water. An added touch of quaintness is given to the gardens by the fact that the old water-works are still in action, so that the unwary visitor, assailed by

fierce jets of spray darting up at him from the terrace
steps, the cracks in the flagstones, and all manner of
unexpected ambushes, may form some idea of the
aquatic surprises which afforded his ancestors such
inexhaustible amusement.

There are few gardens in Italy comparable with
·Val San Zibio ; but in Padua there is one of another
sort which has kept something of the same ancient
savor. This is the famous Botanic Garden, founded in
1545, and said to be the oldest in Italy. The accom-

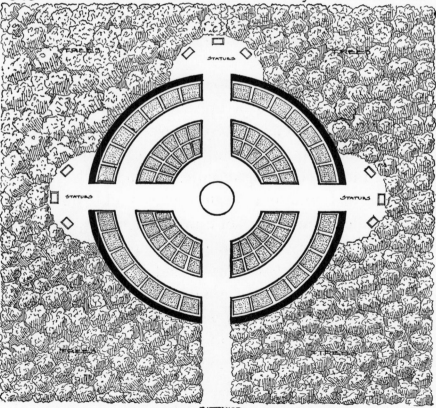

THE BOTANIC GARDEN OF PADUA

panying plan, though roughly sketched from memory, will give some idea of its arrangement. Outside is a grove of exotic trees, which surrounds a large circular space enclosed in a beautiful old brick wall surmounted by a marble balustrade and adorned alternately with busts and statues. The wall is broken by four gateways, one forming the principal entrance from the grove, the other three opening on semicircles in which statues are set against a background of foliage. In the garden itself the beds for " simples " are enclosed in low iron railings, within which they are again subdivided by stone edgings, each subdivision containing a different species of plant.

Padua, in spite of its flat surroundings, is one of the most picturesque cities of upper Italy ; and the seeker after gardens will find many charming bits along the narrow canals, or by the sluggish river skirting the city walls. Indeed, one might almost include in a study of gardens the beautiful Prato della Valle, the public square before the church of Santa Giustina, with its encircling canal crossed by marble bridges, its range of baroque statues of "worthies," and its central expanse of turf and trees. There is no other example in Italy of a square laid out in this park-like way, and the Prato della Valle would form an admirable model for the treatment of open spaces in a modern city.

A few miles from Padua, at Ponte di Brenta, begins the long line of villas which follows the course of the

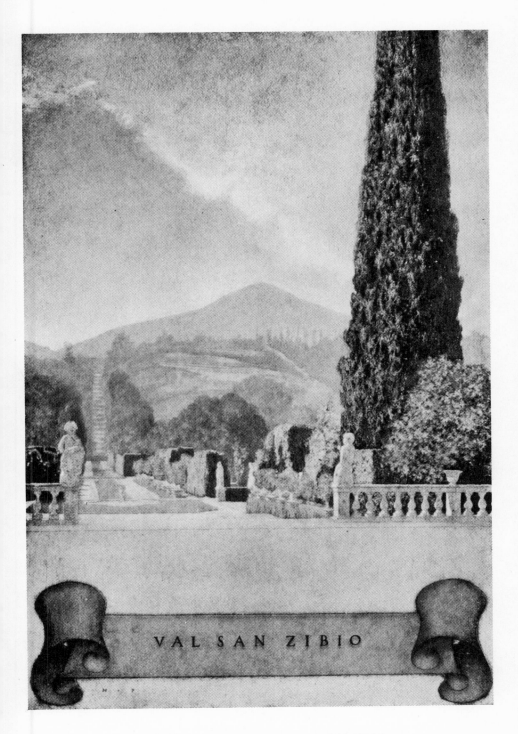

VAL SAN ZIBIO, NEAR BATTAGLIA

river to its outlet at Fusina. Dante speaks in the " Inferno" of the villas and castles on the Brenta, and it continued the favourite villeggiatura of the Venetian nobility till the middle of the nineteenth century. There dwelt the Signor Pococurante, whom Candide visited on his travels; and of flesh-and-blood celebrities many might be cited, from the famous Procuratore Pisani to Byron, who in 1819 carried off the Guiccioli to his villa at La Mira on the Brenta.

The houses still remain almost line for line as they were drawn in Gianfrancesco Costa's admirable etchings, "Le Delizie del Fiume Brenta," published in 1750; but unfortunately almost all the old gardens have disappeared. One, however, has been preserved, and as it is the one most often celebrated by travellers and poets of the eighteenth century, it may be regarded as a good example of a stately Venetian garden. This is the great villa built at Strà, in 1736, for Alvise Pisani, procurator of St. Mark's, by the architects Prati and Frigimelica. In size and elegance it far surpasses any other house on the Brenta. The prevailing note of the other villas is one of simplicity and amenity. They stand near each other, either on the roadside or divided from it by a low wall bordered with statues and a short strip of garden, also thickly peopled with nymphs, satyrs, shepherdesses, and the grotesque and comic figures of the Commedia dell' Arte; unassuming *villini* for the most part, suggesting a life of suburban

neighbourliness and sociability. But the Villa Pisani is a palace. Its majestic façade, with pillared central *corps de bâtiment* and far-reaching wings, stands on the highway bordering the Brenta; behind are the remains of the old formal gardens, and on each side, the park extends along the road, from which it is divided by a

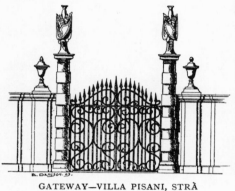

high wall and several imposing gateways. The palace is built about two inner courts, and its innumerable rooms are frescoed by the principal Italian decorative painters of the day, while the great central saloon has one

GATEWAY—VILLA PISANI, STRÀ

of Tiepolo's most riotously splendid ceilings. Fortunately for the preservation of these treasures, Strà, after being the property of Eugène Beauharnais, was acquired by the Italian government, and is now a " villa nazionale," well kept up and open to the public.

In the etching of Costa, an elaborate formal garden with *parterres de broderie* is seen to extend from the back of the villa to the beautifully composed stables which face it. This garden has unfortunately been replaced by a level meadow, flanked on both sides by *boschi*, with long straight walks piercing the dense green leafage of elm, beech and lime. Here and there fragments of garden-architecture have survived the evident

attempt to convert the grounds into a *jardin anglais* of the sentimental type. There is still a maze, with a fanciful little central tower ascended by winding stairs; there is a little wooded "mount," with a moat about it, and a crowning temple; and there are various charming garden-pavilions, orangeries, gardeners' houses, and similar small constructions, all built in the airy and romantic style of which the Italian villa-architect had not yet lost the secret. Architecturally, however, the stables are perhaps the most interesting buildings at Strà. Their classical central façade is flanked by two curving wings, forming charmingly proportioned lemon-houses, and in the stables themselves the stalls are sumptuously divided by columns of red marble, each surmounted by the gilded effigy of a horse.

From Strà to Fusina the shores of the Brenta are lined with charming pleasure-houses, varying in size from the dignified villa to the little garden-pavilion, and all full of interest and instruction to the student of villa-architecture; but unhappily no traces of their old gardens remain, save the statues which once peopled the parterres and surmounted the walls. Several of the villas are attributed to Palladio, but only one is really typical of his style: the melancholy Malcontenta, built by the Foscari, and now standing ruinous and deserted in a marshy field beside the river.

The Malcontenta has all the chief characteristics of Palladio's manner: the high basement, the projecting

pillared portico, the general air of classical correctness, which seems a little cold beside the bright and graceful villa-architecture of Venetia. Burckhardt, with his usual discernment, remarks in this connection that it was a fault of Palladio's to substitute for the recessed loggia of the Roman villa a projecting portico, thus sacrificing one of the most characteristic and original features of the Italian country house to a not particularly appropriate adaptation of the Greek temple porch.

But Palladio was a great artist, and if he was great in his civic architecture rather than in his country houses, if his stately genius lent itself rather to the grouping of large masses than to the construction of pretty toys, yet his most famous villa is a distinct and original contribution to the chief examples of the Italian pleasure-house. The Villa Capra, better known as the Rotonda, which stands on a hill above Vicenza, has been criticized for having four fronts instead of one front, two sides and a back. It is, in fact, a square building with a projecting Ionic portico on each face — a plan open to the charge of monotony, but partly justified in this case by the fact that the house is built on the summit of a knoll from which there are four views, all equally pleasing, and each as it were entitled to the distinction of having a loggia to itself. Still, it is certain that neither in the Rotonda nor in his other villas did Palladio hit on a style half as appropriate or pleasing as the typical manner of the Roman villa-architects,

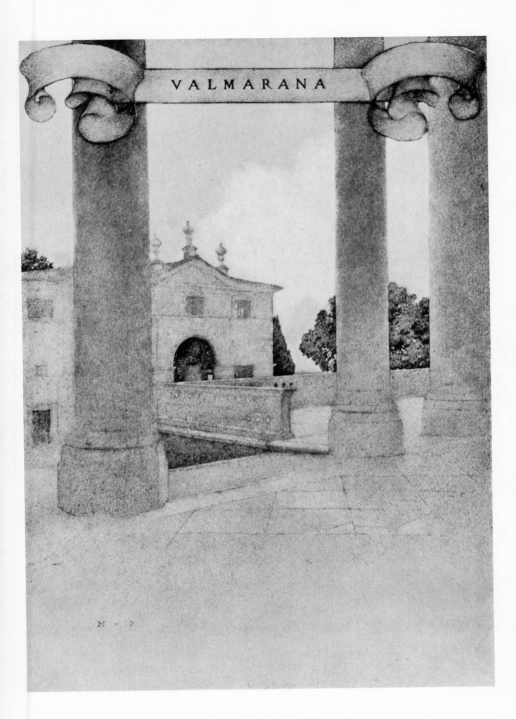

VILLA VALMARANA, VICENZA

with its happy mingling of freedom and classicalism, its wonderful adaptation to climate and habits of life, its capricious grace of detail, and its harmony with the garden-architecture which was designed to surround it.

The Villa Capra has not preserved its old gardens, and at the Villa Giacomelli, at Maser, Palladio's other famous country house, the grounds have been so modernized and stripped of all their characteristic features that it is difficult to judge of their original design; but one feels that all Palladio's rural architecture lacked that touch of fancy and freedom which, in the Roman school, facilitated the transition of manner from the house to the garden-pavilion, and from the pavilion to the half-rustic grotto and the woodland temple.

The Villa Valmarana, also at Vicenza, on the Monte Berico, not far from the Rotonda, has something of the intimate charm lacking in the latter. The low and simply designed house is notable only for the charming frescoes with which Tiepolo adorned its rooms; but the beautiful loggia in the garden is attributed to Palladio, and this, together with the old beech-alleys, the charming frescoed fountain, the garden-wall crowned by Venetian grotesques, forms a composition of exceptional picturesqueness.

The beautiful country-side between Vicenza and Verona is strewn with old villas, many of which would doubtless repay study; but there are no gardens of note in this part of Veneto, except the famous Giusti

gardens at Verona, probably better known to sight-seers than any others in northern Italy. In spite of all their charm, however, the dusky massing of their old cypresses, and their winding walks along the cliff-side, the Giusti gardens preserve few traces of their original design, and are therefore not especially important to the student of Italian garden-architecture. More interesting in this connection is the Villa Cuzzano, about seven miles from Verona, a beautiful old house standing above a terrace-garden planted with an elaborate *parterre de broderie*. Behind the villa is a spacious court bounded by a line of low buildings with a central chapel. The interior of the house has been little changed, and is an interesting example of north Italian villa planning and decoration. The passion of the Italian architects for composition and continuity of design is seen in the careful placing of the chapel, which is exactly on an axis with the central saloon of the villa, so that, standing in the chapel, one looks across the court, through this lofty saloon, and out on the beautiful hilly landscape beyond. It was by such means that the villa-architects obtained, with simple materials and in a limited space, impressions of distance, and sensations of the unexpected, for which one looks in vain in the haphazard and slipshod designs of the present day.

LIST OF BOOKS MENTIONED

ITALIAN

Gianfrancesco Costa — *Le Delizie del Fiume Brenta.* 1750.

Giovanni Falda — *Giardini di Roma.* N. d.

Peter Paul Rubens — *Palazzi di Genova.* 1622.

Rafaello Soprani — *Vite de' Pittori, Scultori ed Architetti Genovesi.* (Second edition, revised, enlarged and supplied with notes by C. G. Ratti. 1768.)

Giuseppe Zocchi — *Vedute delle Ville e d'altri luoghi della Toscana.* 1744.

FRENCH

Le Président de Brosses — *Lettres Familières écrites d'Italie en* 1739 *et* 1740.

L. Dussieux — *Artistes Français a l'Etranger.*

Michel de Montaigne — *Journal du Voyage en Italie par la Suisse et l'Allemagne en* 1580 *et* 1581.

Percier et Fontaine — *Choix des plus célèbres Maisons de Plaisance de Rome et de ses Environs.* 1809.

Marc Antonio del Rè — *Maisons de Plaisance de l'Etat de Milan.* Milan, 1743.

Georges Riat — *L'Art des Jardins.* N. d.

Eugène Emmanuel Viollet-le-Duc — *Dictionnaire Raisonné de l'Architecture Française.* 1858.

LIST OF BOOKS MENTIONED

GERMAN

Jacob Burckhardt	*Der Cicerone.* 1901.
" "	*Geschichte der Renaissance in Italien.* 1891.
Josef Durm	*Die Baustile : Die Baukunst der Renaissance in Italien.* 1903.
Gustav Ebe	*Die Spätrenaissance.* 1886.
Cornelius Gurlitt	*Geschichte des Barockstils in Italien.* 1887.
W. C. Tuckermann	*Die Gartenkunst der Italienischen Renaissance-Zeit.* 1884.

ENGLISH

Michael Bryan	*Dictionary of Painters and Engravers, biographical and critical.* Revised and enlarged by Robert Edmund Graves, B.A., 1886.
G. Burnet, D.D., Bishop of Salisbury.	Some Letters, containing an Account of what seemed most remarkable in Switzerland, Italy, etc. 1686.
John Evelyn	Diary, 1644.

ARCHITECTS AND LANDSCAPE-GARDENERS MENTIONED

ALESSI (GALEAZZO)
1512–1572

Though Alessi was a native of Perugia his best-known buildings were erected in Genoa. Among them are the Villa Pallavicini alle Peschiere, the Villa Imperiali (now Scassi), the Villa Giustiniani (now Cambiaso), the Palazzo Parodi, the public granaries, and the church of the Madonna di Carignano. He also laid out the Strada Nuova in Genoa. His chief works in other places are: the Palazzo Marin (now the Municipio) in Milan; the Palazzo Antinori, and the front of the church of S. Maria del Popolo at Perugia; and the church of the Madonna degli Angeli near Assisi.

ALGARDI (ALESSANDRO)
1602–1654

Algardi, a Bolognese architect, was also distinguished as an engraver and sculptor, and was noted for his figures of children. He built the Villa Belrespiro or Pamphily on the Janiculan, and the Villa Sauli, both in Rome.

AMMANATI (BARTOLOMMEO)
1511–1592

Ammanati, the pupil of Bandinelli and Sansovino, was one of the most distinguished Florentine architects of the sixteenth century, and was also noted for his garden-sculpture. In Florence some of his

best work is seen in the Boboli garden and in the court of the Palazzo Pitti, while the bridge of the S. Trinità is considered his masterpiece. In Rome he built the fine façades of the Palazzo Ruspoli and of the Collegio Romano. The rusticated loggia of the Villa Fonte all' Erta is ascribed to him.

BERNINI (GIOVANNI LORENZO)
1598–1680

Bernini, a Neapolitan by birth, was the greatest Italian architect and sculptor of the seventeeth century. One of his masterpieces in architecture is the church of S. Andrea al Noviziato on the Quirinal, and among his other works in Rome are: the piazza and colonnade of St. Peter's, the Scala Regia in the Vatican, the Palazzo di Monte Citorio, and the fountains of Trevi and the Tritone; at Pistoja the Villa Rospigliosi, at Terni the cathedral, and at Ravenna the Porta Nuova.

BORROMINI (FRANCESCO)
1599–1667

Borromini, a pupil of Maderna, was, next to Bernini, the most original and brilliant exponent of *baroque* architecture in Italy. He was born in Lombardy, but worked principally in Rome. Among his best-known buildings are the church of St. Agnes on the Piazza Navona, that of San Carlo alle quattro fontane, and the College of the Propaganda Fide. In conjunction with Bernini and Maderna, he built the Palazzo Barberini in Rome. Some of his best work is seen in the Villa Falconieri at Frascati.

BRAMANTE (DONATO)
1444–1514

Bramante was born at Urbino, but executed all his early work in Milan, producing the church of S. Maria delle Grazie, the Ospedale Maggiore, and the sacristy of San Satiro, which he not only built, but decorated internally. In Lombardy the early Renaissance of building is called the Bramantesque style. Bramante's works in Rome are: the Tempietto of San Pietro in Montorio, the palace of the Cancelleria, a part of the Vatican, and a part of the Palazzo di San Biagio.

GARDENERS MENTIONED

BROWN (LANCELOT)

1715–1783

Lancelot Brown, known as "Capability Brown," a native of Northumberland, began his career in a kitchen-garden, but, though without artistic training and unable to draw, he became for a time a popular designer of landscape-gardens. He was appointed Royal Gardener at Hampton Court, and laid out the lake at Blenheim. He was considered to excel in water-gardens.

BUONTALENTI (BERNARDO TIMANTE)

1536–1608

Buontalenti, one of the leading Florentine architects of the sixteenth century, was also distinguished as a sculptor and painter. He built the villa of Pratolino and carried on the planning of the Boboli garden. His other works in Florence are: the façades of the Palazzi Strozzi and Riccardi, the Palazzo Acciajuoli (now Corsini), the corridor leading from the Uffizi to the Pitti Palace, and the casino behind San Marco. At Siena, Buontalenti built the Palazzo Reale, and at Pisa, the Loggia de' Banchi.

CAMPORESI (PIETRO)

B. ——, d. 1781

Camporesi, a Roman architect, is mentioned as working with " Moore of Rome" on the grounds of the Villa Borghese.

CARLONE

Several brothers of this name lived in Genoa between 1550 and 1650. They were known as sculptors, painters and gilders, and workers in stucco. The beautiful ceiling of the church of the Santissima Annunziata in Genoa is known to be by one of the Carloni.

CASTELLI (CARLO)

XVII Century

Castelli, who completed the façade of Santa Maria alla Porta, in Milan, was an architect of the school of Maderna. With Crivelli he laid out the gardens of the Isola Bella, near Como.

ARCHITECTS AND LANDSCAPE-

CASTELLO (GIOVANNI BATTISTA)
CALLED IL BERGAMASCO
1509–1579

Giovanni Castello of Bergamo was a pupil of Alessi's and distinguished himself in fresco-painting and sculpture. In Genoa he remodelled the Palazzo Pallavicini (now Cataldi) and built the Palazzo Imperiali. Soprani ("Vite de' Pittori, Scultori ed Architetti Genovesi") says that Il Bergamasco was court-architect to Philip II of Spain and worked on the Escorial. Bryan, in his Dictionary of Painters and Engravers, states that Il Bergamasco was employed on the Prado by Charles V, while his son worked for Philip II.

CRIVELLI
XVII Century

This landscape-gardener worked with Carlo Castelli on the grounds of the Isola Bella, near Como.

FERRI (ANTONIO)
XVII Century

Ferri, a Florentine architect, built the Villa Corsini near Florence, and remodelled the Palazzo Corsini on the Lungarno.

FONTANA (CARLO)
1634–1714

Fontana, one of the most versatile and accomplished architects of his day, was born at Bruciato, near Milan. He was called to Rome as architect of St. Peter's, and collaborated with Berninl on several occasions. In Rome he built the palace of Monte Citorio, the façade of San Marcello, and the Palazzo Torlonia. As a villa-architect his most famous creation is the Garden Palace of Prince Liechtenstein in Vienna. He built the palace on the Isola Bella, and the Villa Chigi, at Cetinale, near Siena, is also attributed to him. He was the author of works on the Vatican and on the antiquities of Rome.

FONTANA (GIOVANNI)
1546–1614

Giovanni Fontana, of Melide, near Lugano, excelled in everything relating to hydraulic work. At the Villa Borghese in Rome, and

in the principal villas at Frascati (Aldobrandini, Taverna, Mondragone), he introduced original designs for the waterworks. In Rome he built the Palazzi Giustiniani and de' Gori, and made the design for the Fontana dell' Acqua Paola, though he did not live to carry it out.

FRIGIMELICA (COUNT GIROLAMO)
XVIII Century

Count Frigimelica, an accomplished Venetian nobleman, built the church of S. Gaetano at Vicenza, and collaborated with Prati in the construction of the Villa Pisani at Strà.

JUVARA (FILIPPO)
1685–1735

Juvara, the most original and interesting Italian architect of the eighteenth century, was a pupil of Carlo Fontana's. His most important work is the church of the Superga near Turin, and his principal buildings are found in or near Turin: among them being the hunting-lodge of Stupinigi and the churches of Santa Cristina and Santa Maria in Carmine. The church of San Filippo in Turin was rebuilt by Juvara, and the royal villa at Rivoli, as well as other villas in the environs of Turin, show his hand. He remodelled the Palazzo Madama in Rome; at Lucca he finished the Palazzo Reale; at Mantua the dome on the church of S. Andrea is by him, and in Lisbon and Madrid, respectively, he built the royal palaces.

LE NÔTRE (ANDRÉ)
1613–1700

Le Nôtre, the greatest of French landscape-gardeners, first studied painting under Simon Vouet, together with Mignard, Lebrun and Lesueur, then succeeded his father as superintendent of the royal gardens. Among his great works are the gardens at Vaux-le-Vicomte, at Sceaux, at Chantilly, and the cascades and park at Saint-Cloud. The park of Versailles, the gardens of the Trianon, of Clagny and of Marly, are considered his masterpieces. When he visited Italy he remodelled the grounds of the Villa Ludovisi. He was frequently consulted by the Elector of Brandenburg and other notable foreigners.

ARCHITECTS AND LANDSCAPE-

LIGORIO (PIRRO)
1493-1580

Ligorio, the Neapolitan architect, was also distinguished as antiquary, sculptor and engineer; he worked much in *sgraffiti*. He built the beautiful Villa Pia in the Vatican gardens, and the Villa d'Este at Tivoli, and made additions to the Vatican. The Library in Turin possesses his numerous manuscripts, some of which have been published. His best-known works are "An Attempt to Restore Ancient Rome" and "The Restoration of Hadrian's Villa," the plates for which were engraved on copper by Francesco Contini in 1751.

LIPPI (ANNIBALE)
B. ——, d. 1581

Lippi is generally said to have been the son of Nanni di Baccio Bigio, the architect and sculptor, though some biographers declare them to have been the same person. Assuming Lippi to have had a separate identity, only two of his works are known: the church of S. Maria di Loreto, .near Spoleto, and the Villa Medici in Rome. His fame rests on the latter, which became the model of the Roman *maison de plaisance*.

LONGHENA (BALDASSARE)
1604-1682

Longhena, the most distinguished architect of the late Renaissance in Venetia, gave all his time and work to his native city. Among the buildings he erected there are: S. Maria della Salute, S. Maria ai Scalzi, the Ospedaletto, the cloister and staircase in San Giorgio Maggiore, the Palazzo Pesaro, and the Palazzo Rezzonico (now Zelinsky).

LUNGHI OR LONGHI (MARTINO) THE ELDER
XVI Century

Lunghi, born at Viggiù in the Milanese, in the second half of the sixteenth century, built the Villa Mondragone at Frascati, in 1567, for Cardinal Marco d'Altemps. The villa was enlarged by Gregory VII, and later by Paul V and his nephew, Cardinal Scipione Borghese.

GARDENERS MENTIONED

MARCHIONNE (CARLO)
1704–1780

Marchionne was the architect of the Villa Albani near Rome, built in 1746.

MICHELANGELO (SIMONE BUONARROTI)
1475–1564

The great architect, sculptor and painter, was born in Florence, where he built the Laurentian Library and the chapel of S. Lorenzo, with the cupola of the sacristy. In Rome he built the Palazzo de' Conservatorii on the Capitoline hill, the cornice of the Palazzo Farnese, the Porta del Popolo and the Porta Pia. His model for the dome of St. Peter's was carried out except as to the lantern. Tradition assigns to him the Villa ai Collazzi (now Bombicci) near Florence.

MONTORSOLI (FRA GIOVANNI ANGELO)
1507–1563

Fra Giovanni Montorsoli, a Florentine monk of the Servite Order, was a sculptor, and studied under Michelangelo. He was early called to Genoa, where he decorated the church of San Matteo (the church of the Doria family) and built the famous villa in the harbour for the Admiral Andrea Doria. The Villa Imperiali, at San Fruttuoso, near Genoa, is also attributed to Montorsoli. One of his best works is the high altar in the church of the Servi at Bologna.

MOORE (JACOB)
1740–1793

Moore, a Scotch landscape-painter — known as " Moore of Rome "— was patronized by Prince Borghese, and remodelled the grounds of the Villa Borghese in the style of the *jardin anglais*.

MORA
XVII Century

A Roman engineer of the name built some of the waterworks on the Isola Bella, near Como, in the seventeenth century.

NOLLI (ANTONIO)
XVIII Century

Nolli laid out the grounds of the Villa Albani near Rome, in 1746.

NOLLI (PIETRO)
XVIII Century

Pietro Nolli is also mentioned as one of the landscape-gardeners who laid out the Villa Albani.

OLIVIERI (ORAZIO) OF TIVOLI
XVI Century

Olivieri was employed as an engineer of the waterworks at the Villa d'Este at Tivoli and the Villa Aldobrandini at Frascati.

PALLADIO (ANDREA)
1508–1580

Palladio, the great Venetian architect, was born at Vicenza. He turned the development of Italian Renaissance architecture in the direction of pure classicalism, and was a master of proportion in building. At Vicenza he rebuilt the Sala della Ragione, and built the Palazzi Tiene and Valmarana and the Teatro Olimpico; while the Villa Capra or Rotonda, near Vicenza, is his work, and also the Villa Giacomelli at Maser. In Venice he erected the churches of San Giorgio Maggiore and Il Redentore, also the Villa Malcontenta near Fusina on the Brenta. Palladio published a "Treatise on Architecture" and "The Antiquities of Rome."

PARIGI (GIULIO)
B. ——, d. 1635

Parigi was a Florentine architect, engineer and designer. As far as is known, he worked entirely in Florence and its environs. He is the architect of the court and arcade of Poggio Imperiale, the cloister of S. Agostino, the Palazzo Marucelli (now Fenci), the Palazzo Scarlatti, and a part of the Uffizi.

PERUZZI (BALDASSARE)
1481–1537

Peruzzi, who was both architect and painter, divided his time between Rome and Siena, where he was born. He built the Villa Vicobello

near Siena, as well as that of Belcaro. The well-known Palazzo Massimi alle Colonne in Rome is his work, also the Villa Trivulzio near Rome.

PIRANESI (GIOVANNI BATTISTA)
1720–1778

Piranesi, the famous Venetian etcher and engraver, was specially noted for his etchings of famous buildings, and has been called " The Rembrandt of Architecture." He was also an architect, and worked on the church of S. Maria del Popolo in Rome. While there he also remodelled the chapel of the Priory of the Knights of Malta, and probably laid out the grounds. Piranesi published over twenty folio volumes of engravings and etchings.

PONZIO (FLAMINIO)
1575–1620

Ponzio, a Lombard architect, built the loggia of the Villa Mondragone at Frascati, and the Palazzo Sciarra, and finished the Borghese Chapel in the church of S. Maria Maggiore in Rome.

PORTA (GIACOMO DELLA)
1541–1604

Della Porta, a Milanese architect, was a pupil of Vignola's. His great work was the finishing of the dome of St. Peter's in Rome, in doing which he followed Michelangelo's plan, but improved the curve. His other works in Rome were: the churches of Il Gesù, S. Luigi de' Francesi, S. Catarina de' Funari, the Palazzo Paluzzi, the façade of the Palazzo Chigi, the famous fountains in the Piazza d'Araceli and the Piazza Navona (for which Bernini supplied the sculpture), and the Fontana delle Tartarughe. In Genoa he finished the church of the S. S. Annunziata, and he was employed on the Villa d'Este at Tivoli and the Villa Aldobrandini at Frascati.

PRATI
XVIII Century

Prati collaborated with Count Frigimelica in building the Villa Pisani, at Strà near Venice, in the eighteenth century.

ARCHITECTS AND LANDSCAPE-

RAINALDI (GIROLAMO)
1570–1655

Rainaldi was a Roman and his principal works are in Rome. He planned the church of S. Agnese; built the façade of S. Andrea della Valle, the façade of S. Maria in Campitelli, and the Palazzo Pamphily on the Piazza Navona. He added two pavilions to the Farnesina, and designed the grounds of the Villa Borghese and the gardens of the Villa Mondragone at Frascati. In Bologna he built the church of S. Lucia.

RAPHAEL SANZIO
1483–1520

Raphael succeeded Bramante as chief architect of St. Peter's. His most important villa is the famous Villa Madama near Rome. The Farnesina in Rome was built by him, and he laid out the gardens of the Vatican. His other works in Rome are the Palazzo Caffarelli (now Stoppani) and the Capella Chigi. In Florence he designed the façades of the church of San Lorenzo and of the Palazzo Pandolfini (now Nencini).

REPTON (HUMPHREY)
1752–1818

Repton, who was born at Bury St. Edmunds, began life as a merchant, but having failed in his business, became a landscape-gardener. He published " Observations on Landscape Gardening " (1803), and is the best-known successor of " Capability Brown " in the naturalistic style of gardening.

ROMANO (GIULIO DEI GIANNUZZI — ALSO CALLED GIULIO PIPPI)
1492–1546

As Raphael's pupil, Giulio Romano painted the architectural backgrounds of Raphael's frescoes in the Vatican, and this led to his studying architecture. His masterpiece is the Palazzo del Tè at Mantua, where he also built a part of the Palazzo Ducale. He carried out Raphael's decorations in the Villa Madama.

GARDENERS MENTIONED

RUGGIERI (ANTONIO MARIA)
XVIII Century

Ruggieri built the Villa Alario (now Visconti di Saliceto) on the Naviglio near Milan, and the façade of the church of S. Firenze in Florence. He also remodelled the interior of Santa Felicità in Florence, and in Milan he built the Palazzo Cusani.

SANGALLO (ANTONIO GIAMBERTI DA)
1455–1534

Antonio da Sangallo was a brother of Giuliano, and famous as a carver of crucifixes. He altered Hadrian's tomb in Rome into the Castle of St. Angelo, and laid out a part of the Vatican gardens. The church of the Madonna di S. Biagio in Montepulciano and the fortress of Cività Castellana were built by him.

SANGALLO, THE YOUNGER (ANTONIO CORDIANI DA)
1483–1546

This Sangallo was a nephew of the other Antonio, and a pupil of Bramante's. After Raphael's death he became the leading architect of St. Peter's. The fortress at Cività Vecchia is his work. In Rome he planned the outer gardens of the Vatican and built the right-hand chapel in S. Giacomo degli Spagnuoli, the beautiful Palazzo Marchionne Baldassini, the Palazzo Sacchetti, and the greater part of the Palazzo Farnese.

SANGALLO (GIULIANO GIAMBERTI DA)
1445–1516

Giuliano da Sangallo, the Florentine architect, was also noted as an engineer and a carver in wood. His great work is the villa at Poggio a Caiano near Florence, with a hall having the widest ceiling then known. He also built the Villa Petraia at Castello, near Florence, and in or near Florence the sacristy and cloister of San Spirito, the cloister for the Frati Eremitani di S. Agostino, and the villa of Poggio Imperiale. Among his other works are: the Palazzo Rovere near San Pietro in Vincoli, in Rome, and the Palazzo Rovere at Savona. Sangallo also constructed many fortresses. After Bramante's death he worked with Raphael on St. Peter's.

ARCHITECTS AND LANDSCAPE-

SANSOVINO (JACOPO TATTI)
1487-1570

Sansovino, though a Florentine by birth, worked principally in Venice. He was equally distinguished as sculptor and architect. In the latter capacity he built in Venice the Zecca or Mint, the Loggietta, the Palazzo Cornaro, the Palazzo Corner della Cá Grande, the Scala d'Oro in the Doge's palace, the churches of San Martino and San Fantino, and his masterpiece, the Library of San Marco. In Rome the Palazzo Gaddi (now Nicolini) was built by him.

SAVINO (DOMENICO)
XVIII Century

Savino is mentioned among the landscape-gardeners who remodelled the grounds of the Villa Borghese.

TITO (SANTI DI) OF FLORENCE
1536-1603

Santi di Tito of Florence was known as an historical painter, and also as a builder of villas at Casciano and Monte Oliveto. An octagonal villa at Peretola was built by him, and he did some decorative work in the Villa Pia. In Florence he built the Palazzo Dardinelli.

IL TRIBOLO (NICCOLÓ PERICOLI)
1485-1550

Il Tribolo, the Florentine sculptor, studied under Sansovino. He became known for his beautiful designs in tile-work, of which the Villa Castello near Florence shows many examples. He collaborated with Ammanati in laying out the Boboli garden, and the great grotto at Castello is his work.

UDINE (GIOVANNI DA)
1487-1564

Giovanni da Udine, born, as his name indicates, in the chief city of the province of Friuli, was one of the most celebrated decorative artists of his day. He studied under Giorgione and Raphael, and became noted for his stained glass and for the invention of a stucco

as durable as that of the Romans. His stucco-work in the Villa Ma-
dama and in the loggias of the Vatican is famous, and part of the deco-
ration of the Borgia rooms in the Vatican is his work. Michel-
angelo's chapel of the Medici in Florence was painted and decorated
in stucco by Udine, and he carried out, in painting, some of Ra-
phael's designs for the great hall of the Farnesina. The Palazzo
Grimani in Venice and the Palazzo Massimi alle Colonne in Rome
were partly decorated by him.

VAGA (PIERIN DEL)
1500–1547

Del Vaga, whose real name was Pietro Buonaccorsi, was born near
Florence. He was a pupil of Raphael's, and after the latter's death
was employed in finishing a part of his work in the Vatican. Almost
all del Vaga's work was done in Genoa, where he painted the state
apartments in the Villa Doria. The charming plaster decorations
in the Palazzo Pallavicini (now Cataldi) are by him, and also the
Hercules cycle in the Palazzo Odero (now Mari).

VASANZIO (GIOVANNI)
B. ——, d. 1622

Vasanzio, known also as Il Fiammingo, but whose real name was John
of Xanten, was a Flemish architect who came to Italy and had con-
siderable success in Rome. He built the Villa Borghese in Rome
and designed the fountains of the inner court of the Villa Pia. He
also worked on the Villa Mondragone at Frascati and succeeded Fla-
minio Ponzio as architect of the Palazzo Rospigliosi in Rome.

VASARI (GIORGIO)
1511–1574

Vasari, who was born at Arezzo, was a pupil of Michelangelo and
Andrea del Sarto. Though he considered himself a better painter
than architect, it is chiefly as the latter that he interests the modern
student. He built the court of the Uffizi in Florence and planned the
Villa di Papa Giulio in Rome; painted the ceiling of the great hall of
the Palazzo Vecchio in Florence, and carved the figure of Architecture
on the tomb of Michelangelo in Santa Croce. He is, however, chiefly
famous for his lives of the Italian painters and architects.

ARCHITECTS MENTIONED

VIGNOLA (GIACOMO BAROZZI DA)
1507–1573

Vignola, one of the greatest architects of the sixteenth century, born at Vignola, in the province of Modena, followed Michelangelo as the architect of St. Peter's. The Villa Lante at Bagnaia, near Viterbo, is attributed to him. In Rome he built the celebrated Villa di Papa Giulio, though the plan was Vasari's; also the garden-architecture of the Orti Farnesiani on the Palatine. His masterpiece is the palace at Caprarola, near Viterbo. He also built the great Palazzo Farnese at Piacenza, various buildings at Bologna, and the loggia of the Villa Mondragone at Frascati. His church of the Gesù in Rome greatly influenced other architects. His text-book on the Orders of Archi tecture is one of the best-known works on the subject.

INDEX

INDEX

INDEX

INDEX